CW01161077

Helga Himen

Ringberg Castle on Tegernsee

Helga Himen

Ringberg Castle on Tegernsee

SWAN SONG OF WITTELSBACH BUILDING –
PLACE OF SCIENTIFIC MEETINGS

Revised for publication
by Heiderose Engelhardt

With essays by
Otto Meitinger and Manfred Rühle

Deutscher Kunstverlag München Berlin

The Deutscher Kunstverlag wishes to express particular thanks to Axel Hörmann, Max Planck Society, Director of the Ringberg Castle conference venue, and Gottfried Plehn, Max Planck Society, Press and Public Relations Department, who have supported this publication with unswerving commitment.

IMPRINT

General Editor Rudolf Winterstein
Translation Joan Clough
Reader Michelle Tilgner

Typesetting and Layout Haak & Nakat, Munich
Cover Manfred Manke

Scans Lana-Repro, Lana (South Tyrol/I)
Printing and Binding Printer Trento, Trent (I)

Bibliographical information from the German National Library: The German National Library has registered this publication in the German National Bibliography; detailed bibliographical data are available online at http://dnb.d-nb.de.

© 2008 Deutscher Kunstverlag München Berlin
ISBN 978-3-422-06828-5

Front cover
Ringberg Castle. View from the north-west

Back cover
Ringberg Castle. The Duke's writing room (fig. 99)

Frontispiece
Aerial view of Ringberg Castle, in the background the snow-covered Hirschberg

End papers
Diaper pattern from the soffit in the Duke's writing room: Stencil painting washed with oil and wax casein paint

Illustration pp. 8/9
1 View across Tegernsee looking north, in the foreground the castle complex on the Ringberg; on the far side of the lake Tegernsee Abbey with the former abbey church

Contents

7 FOREWORD OF THE PRESIDENT OF THE MAX PLANCK SOCIETY

10 Introduction

12 The Tegernsee valley as a heritage landscape

14 The royal patron – Duke Luitpold in Bavaria
14 HIS LIFE
21 FAMILY BACKGROUND

22 The 'court artist' – Friedrich Attenhuber
22 STAGES IN THE ARTIST'S LIFE
24 FRIEDRICH ATTENHUBER'S PATH TO BECOMING 'A MATURE ADEPT AND AN INDEPENDENT ARTIST'
30 ATTENHUBER AS THE ALL-ROUND ARTIST ON THE RINGBERG
35 THE RELATIONSHIP BETWEEN ARTIST AND PATRON

44 The metamorphosis of the villa into a castle
44 THE 'ANSITZ' ON THE RINGBERG
55 FROM 'ANSITZ' TO 'FORTRESS'

88 The interior of Ringberg Castle
88 FURNISHINGS AND APPOINTMENTS
90 CHRONOLOGY OF THE INTERIOR DESIGN
93 THE CASTLE'S INTERIOR DECORATION CONCEPT

97 A TOUR THROUGH THE CASTLE
97 The ground floor
Staging receptions
The Garden Room
The writing room
The Great Hall
The Music Room
The dining room
The 'Landshut Stair'
The Witches' Room
The 'sitting room'

122 The first floor
The Duke's bedchamber
The Red Drawing Room
The Spring Room
The pine-panelled rooms
The guest rooms

130 Ringberg and its place in cultural history

130 VILLA, PALACE OR CASTLE?
The villa
The palace
The castle

132 THE HISTORICAL BACKGROUND OF THE RINGBERG ARCHITECTURE
The quest for models in the family tradition
Palaces and castles built in the 19th and 20th centuries
Travel impressions
Ringberg Castle – a unique ensemble in context
Ringberg Castle – tradition and contradiction

139 Ringberg Castle and the Max Planck Society

139 *HELGA HIMEN*: BETWEEN SCIENCE AND CONSERVATION: CONVERSION OF THE CASTLE BY THE MAX PLANCK SOCIETY

147 *OTTO MEITINGER*: 'WITH THE TIMES' – RINGBERG CASTLE, THE MAX PLANCK SOCIETY AND CHANGES IN TASTE

151 *MANFRED RÜHLE*: RINGBERG CASTLE TODAY – RECOLLECTIONS OF EXTRAORDINARY SCIENTIFIC CONFERENCES

158 THE AUTHORS
159 PHOTO CREDITS

FOREWORD OF THE PRESIDENT OF THE MAX PLANCK SOCIETY

Twenty-five years ago, in 1983, the Max Planck Society opened its conference centre at Ringberg Castle high above lake Tegernsee. Anyone fortunate enough to have ever given lectures and engaged in discussions, spent the night and dined in those splendid rooms will have indelible recollections of the castle and its unforgettable setting. The present book is to provide interested visitors with glimpses into the castle's architectural history, its art-historical significance and the current uses to which Ringberg Castle is being put.

After the death of its builder, Duke Luitpold in Bavaria in 1973, the castle went to the Max Planck Society under the terms of a contract concluded with Duke Luitpold during his lifetime, specifying that it should be used solely for scientific purposes. At first, a trial period provided for a limited use in the finished sections of the castle, which could accommodate conferences attended by ten to twenty persons. Generous donations from the Munich Re Group and the Bavarian Landesstiftung as well as the fortune bequeathed by Duke Luitpold made it possible for the Max Planck Society to restore and extensively renovate the castle from 1981 to 1983. I would like to take this opportunity to thank the donors once again for their generosity and support. A new conference and lecture hall now provides sixty scientists with space for conferences, and thirty-four guest rooms ensure an enjoyable stay at the castle. The relatively small size makes for an intense exchange of ideas amongst conference participants.

Since then, the castle has been run like a small hotel. In 2007, it served as a venue for seventy-five events, each lasting several days, attended by nearly three thousand visitors, of whom about half were from abroad. Scheduling conferences at Ringberg can be quite difficult because the castle tends to be booked up nearly two years in advance, so that about thirty per cent of requests must unfortunately be turned down. This resounding popularity shows how pleasant the setting is at Ringberg Castle. 'Lord of the Manor' Axel Hörmann and his team of ten employees, including room service, gardeners and laundry personnel, create the ideal ambience for conferences and seminars, and all this without additional funding: currently the conferences pay for themselves while maintenance and repair work is covered by the income from the 'Luitpold Fund', the endowment donated by the Duke.

It is by now a time-honoured tradition of the Max Planck Society to organise central symposia dealing with interdisciplinary scientific issues at Ringberg. Conferences on embryo research and the identification of new areas of research as well as a symposium on 'peer review' have been held there. Since 2006, scientists have been invited to conferences at the castle hosted jointly by the renowned British scientific journal Nature and the Max Planck Society. Every two years the castle is open to the public on a big Open Day for anyone interested in visiting. Under the auspices of the Oleg Kagan Music Festival, two open-air concerts are performed annually at the castle.

In my capacity as President of the Max Planck Society, I have the opportunity from time to time to welcome international delegations or conference participants to Ringberg Castle. This is always especially enjoyable because visitors from abroad in particular tend to be impressed by the castle architecture and the Tegernsee scenery. Personally, I have mixed feelings about the building. To today's tastes, the medieval fortress look is overdone and the same holds true of many aspects of the interiors and paintings. Still, the setting and the ambience are peerless. I am sure none of our directors would want to miss the conferences there. During my tenure as director of the MPI for Biophysical Chemistry, I and my department regularly held a meeting there before Christmas. I still remember one of those pre-Christmas meetings: The Ringberg team had lavished time and care on decorating the rooms with fir branches and a long string of apples on the mantelpiece. When we met again in the entrance hall after spending the first night there, the apples bore visible traces of the riotous mood prevailing in the unofficial part of the conference programme. I suspect Mr Hörmann was relieved when I took over as President in 2002 and the department meetings gave way to receptions greeting more sedate guests.

The success story of Ringberg Castle is bound to continue. Interpersonal conversations and meetings will remain indispensable even in the age of the internet, e-mail, mobile telephones and videoconferencing. I wish our conference centre many more happy years, with a lot of productive conferences and discussions!

Peter Gruss
President of the Max Planck Society

Introduction

'His Royal Highness Luitpold, Duke in Bavaria, is, as we have been informed, said to be thinking about commissioning a magnificent castle to be built, which will be modelled after Neuschwanstein … The building is to be completed by 1915 and work on it will commence forthwith, in the spring of 1912.'

Thus were the building plans of twenty-one-year-old Luitpold, Duke in Bavaria, first made public, in a brief note in the Tegernsee gazette See-Geist on 19 January 1912. Viewed in retrospect, realising that project entailed drawing up a great many plans based on a wealth of ideas as well as adopting building measures that would be executed, altered and later rejected. The 'castle modelled after Neuschwanstein' was a vague notion: no clear statement on how the projected building was to look was issued, so a great deal of scope was provided for all manner of conjecture. The metamorphosis of the structure from an idiosyncratic villa to a palace to a fortified castle that would never be completed was followed with bemusement, possibly also with suspicion.

The Duke was said to have discovered the ideal site on a spur of the Ringberg. He not only found one of the most beautiful locations on Tegernsee, with a breathtaking view to the north across the entire lake and to the south far into the Kreuth valley, encompassing the Wallberg, Setzberg and Hirschberg as well as the Tyrolean range, but also a mystical place, which, as legend has it, is one of the favourite spots for covens to convene in Bavaria.

Over fifty years later – long after the end of the monarchy in Bavaria, after two world wars and shortly before the student movement set in – a news magazine also mentioned the building project on the Ringberg, in an article entitled 'The Rich in Germany': 'Undisturbed by the populace on Tegernsee, Luitpold, Duke in Bavaria, has, for a generation, been engaged in building on the Ringberg, not all that far from the little Chancellor's bungalow, a fairytale castle that the Bavarian authorities have refused listed status. This unusual object of a belated ducal romanticism has by now devoured as much funding as a modern hospital, but is still not ready to be inspected by the people. He may be assured, of course, of the good will of the people.' (Peter Brügge, 'Die Reichen in Deutschland', Der Spiegel, 20, no. 37 (1966), p. 53f.)

The patron of this undertaking, Duke Luitpold of the House of Wittelsbach, who at the time was seventy-six years old, presumably did not find the journalist's assumption that he might be assured of the good will of the people ungratifying. What is, on the other hand, less certain is whether he cared if the people inspected the 'fairy-tale castle' during his lifetime. When a contemporary inquired: 'What do you actually get out of the castle? Now you have spent a lifetime building it and don't even live in it!' the Duke is said to have replied 'that the Bavarian people would later look at it like the castles of Ludwig II'. With 'later', he surely meant 'not in my lifetime; if at all, then after my death'. In the early 1950s, the royal patron opened the gates of the castle on a few weekends, but less in the interests of visitors than with an eye to the tax advantages to be expected if it could be established that the public was interested in keeping up the castle because of its importance to art, scholarship or homeland defence. In 1952, Luitpold ceased paying the property tax on the castle, which marked the beginning of a lawsuit that dragged on for decades, pursued in vain by the Duke against the parish of Kreuth through several courts of appeal. At that time, he was unable to make any headway with the art-historical argument that the castle should be preserved as the 'last monument to 19th-century Romanticism'.

In 1973, after the Bavarian Law for the Conservation of Historic Monuments had been passed and work had begun on listing buildings throughout Bavaria, Ringberg Castle was also granted monument status, on the list drawn up for the rural district of Miesbach.

On the Duke's death, however, Ringberg Castle did not become another of Tegernsee's tourist attractions. Duke Luitpold had bequeathed it to the Max Planck Society, which turned it into an international forum where scientists can meet – this was done with great sensitivity and respect for all the architectural feats that had been achieved up to that date. The building was ultimately adapted for the Society's purposes and put to an appropriate use.

The 'unusual object of a belated ducal Romanticism' on the Ringberg, on which construction began in 1912 and which was still unfinished on the death of the man who had commissioned it after over sixty years of uninterrupted building, co-exists in an uneasy relationship with the so-called royal castles built by Ludwig II. Duke Luitpold definitely intended a link with King Ludwig II, his cousin twice removed. What the two had in common was a passion for building that drove them to the brink of financial ruin. Another trait they shared was a pronounced penchant for Romanticism, which made them seek to revive beautiful sites at exposed and remote locations. In those natural theatres, they staged an idealised past built of their fantasies. Any sustainable realisation of their notions was, however, thwarted by social change. Thus, another similarity between the two was their failed utopias.

Although there are some parallels in mindset between the royal builders, the designs of the buildings they erected contrast quite sharply with one another. The large hilltop castle on the Ringberg is certainly not a 'fairy-tale castle'. Although it developed out of a profoundly Romantic attitude, it is not a place where romantic feelings or associations are immediately elicited. With its fortifications modelled on medieval defensive architecture and the rest of the complex blending Renaissance and Alpine building traditions, the monumental ensemble looks forbiddingly cold. Indeed, unlike the creations of Ludwig II, which were conceived with pomp and circumstance in mind, it looks decidedly austere and uninviting.

Although the building on the Ringberg is of such recent date, it is difficult to 'read'. Only a study of it from the standpoint of architectural history makes it possible to trace the ideas behind the project. Then, and only then, can visitors understand that the castle, which may at first sight resemble a mere curiosity, occupies a special place in art and cultural history. This unfinished complex, an eclectic blend of villa, fortress and castle, is not only instructive as 'applied art history' conveyed through its architecture. The furnishings and appointments of the main building have also survived intact, providing a survey of the manifold changes in style that took place in the first half of the 20th century. Indeed, a glimpse inside the castle affords an overview of the aesthetic contradictions informing the interior design of the day, embracing late Historicism, Art Nouveau, Art Deco, the regional vernacular style, Neo-classicism, modernism and National Socialist classicism.

Ringberg Castle represents the final testimony to the Wittelsbach architectural tradition. Duke Luitpold's pedigree was equal to that of the Wittelsbachs who had commissioned so many castles and fortresses into the 19th century but he belonged to a generation that had gone through two world wars and experienced the complete breakdown of longstanding political, social and cultural values. Needless to say, the end of nearly eight centuries of Wittelsbach rule in Bavaria also directly affected the Duke's family. In its quintessential oddness, the building on the Ringberg sheds light on a very particular aspect of 20th-century social history: the role of the aristocracy following the demise of the monarchy and its striving for a new self-image. Like the building itself, the man who commissioned Ringberg Castle found neither an adequate form of existence nor usefulness in life. Ringberg Castle, which, after being under construction for more than sixty years also housed Duke Luitpold's urn grave, can also be interpreted as this Wittelsbach's 'monument to himself', marking the simultaneous extinction of the collateral line of the Dukes in Bavaria.

Like the architectural achievements of King Ludwig II, all of which remained the work of artists and artisans who long remained unknown even to experts, only the name of the man who commissioned the Ringberg is familiar to a limited circle: his 'personal architect' is virtually unknown. Friedrich Attenhuber, who was responsible for the artistic conception of large parts of the castle, has been only rarely mentioned, nor have he and his work ever been sufficiently acknowledged. The building with its furnishings and appointments represents a major part of that talented artist's life's work. Tracing the paths taken by the lives of both patron and artist may serve to illuminate the intentions and the aesthetic aims of its creators and the conditions under which the castle and its grounds came into being.

In the following, various aspects of the Ringberg are to be looked at under separate headings – ranging from the typography of the castle through its patron and his 'personal' or 'court artist' to the architecture, interior design and building typology – with the aim of facilitating an understanding of the Ringberg Castle phenomenon, while revealing the uniqueness of the complex and its aesthetic value as a total work of art.

The Tegernsee valley as a heritage landscape

The mighty towers of Ringberg Castle on a slope in the southern Tegernsee valley can be espied from afar. The castle and its grounds are reminiscent of a medieval mountain fortress, ensconced on the southern slopes of the Ringberg as if keeping watch over the lake and the approaches to the Kreuth valley. The Ringberg (1000 m; 3280 ft) is named after Ringsee, a roughly annular indentation on the south-western shore of Tegernsee. It forms the southern flank of the Hirschberg (1790 m; 5872 ft), which is part of the western Tegernsee range.

Tegernsee, one of the lakes fringing the northern foothills of the Alps, is set against a magnificent mountain backdrop. Its western shore is a 'grassy, hilly region, where small towns, farmsteads and mills peep out of a leafy setting' – thus a description penned in 1895. Since then, property development and traffic volume have increased exponentially at the foot of the castle, especially in Bad Wiessee, Rottach-Egern and along the Weissach. This is not surprising in view of the fact that the area is not only ideal for pursuing leisure activities but also as a place to live.

Since time immemorial, the Tegernsee valley has exerted an enormous pull and is regarded as one of the oldest and most important cultural landscapes in Bavaria. In the early 19th century, it was revitalised by the House of Wittelsbach and soon came to epitomise 'Royal Bavaria'.

Founded in the eighth century by Benedictine friars, Tegernsee abbey was secularised during the Napoleonic Wars and converted in 1817 into a summer residence by Maximilian I Joseph, the first king of Bavaria. Owing to the presence of the court, its officials and illustrious guests, the nobility and artists, who, following a Romantic bent, were drawn to the towering Alps and their foothills, the area around the lake thus began a new chapter in its architectural, cultural and social history. The king also had the Benedictine monasteries at Kaltenbrunn and Wild-

2 The 'Royal Tegernsee maison de plaisance', lithograph after H. Adam Ertinger, after 1817. Maximilian I Joseph, King of Bavaria, acquired the Tegernsee abbey in 1817 and had it converted into a summer residence.

3 Ringberg Castle. View from the 'inner ward' across the Tegernsee valley

bad Kreuth restored. The Kreuth valley and its mountains became increasingly frequented by spa and summer guests, including potentates and high-ranking persons from all over Europe. The royal model estate at Kaltenbrunn on the Gmund shore of Tegernsee became a favourite attraction, an observation point and a popular motif amongst painters.

In all those respects, particular importance accrued to the construction site on the Ringberg since it afforded unobstructed views north to Tegernsee Palace and across the lake all the way to Kaltenbrunn and south far into the Kreuth valley. Hence the location of the castle ensured that it fulfilled an architectural function unprecedented in the area as a node in the system of coordinates of a heritage landscape comprising historic buildings on a grand scale. As a youthful patron of architecture, Duke Luitpold in Bavaria now positioned his castle in the midst of these buildings steeped in tradition and history. Apart from the fact that Luitpold spent part of his childhood in the area with his uncle, Karl Theodor, and that the family vault of the Dukes in Bavaria was in Tegernsee, a prime motive for building the castle on the Ringberg is clear: Luitpold, who, although his position was insignificant measured against his family's historical and political importance, permitted himself such a pointedly monarchical gesture, positioning himself both squarely at the centre and above the Wittelsbach estates. Ringberg Castle is the latest and the sole new building in the series of properties that had been taken over or erected by the Wittelsbachs in the Tegernsee area since 1806.

The Tegernsee valley as a heritage landscape

The royal patron – Duke Luitpold in Bavaria

HIS LIFE

'I was born in Munich on 30 June 1890, the son of Duke Max Emanuel in Bavaria and Duchess Amalie, née Princess of Saxe-Coburg-Gotha, Duchess of Saxony.'

Thus wrote Duke Luitpold in the CV he submitted with his doctoral dissertation on 30 May 1922. His father, Maximilian Emanuel, born at Possenhofen Palace on Lake Starnberg in 1849, was the youngest of eight children born of the union of Duke Maximilian Joseph in Bavaria (1808–1888) and Ludovica Wilhelmine of Bavaria (1808–1892), a daughter of King Maximilian I Joseph of Bavaria. By far the best-known of his father's siblings were Elisabeth Amalie Eugenie, later Empress of Austria, affectionately called 'Sisi', and Karl Theodor, who took a doctorate in medicine and, as a sought-after ophthalmologist, founded an ophthalmic clinic in Munich. Luitpold had two elder brothers, Siegfried (1876–1952) and Christoph (1879–1963). Luitpold's godfather, the third Wittelsbach prince to live at Biederstein Palace in Munich's Schwabing district, was no less a personage than Luitpold, Prince Regent of Bavaria.

In 1893, while still a child, Luitpold lost his father. A year later – the Duke had just turned four – his mother, Amalie, died at the age of forty-five. Now an orphan, Luitpold was in the care of his grandmother, Clementine, Duchess of Saxe-Coburg, although he grew up mainly in the family of his uncle, Karl Theodor, Duke in Bavaria, and his wife, Maria José of Braganza. At an early age, Luitpold was familiar with the estates owned by the Wittelsbach ducal collateral line, especially those on Tegernsee and Lake Starnberg. Since 1888, Karl Theodor had been head of his family line, the dukes in Bavaria. He had lived since 1876 on Tegernsee to administer for the collateral line the royal estates there, which he had inherited from his mother, Ludovica. At seasonal or family festivities, the ducal family also convened in Wildbad Kreuth or Possenhofen.

Instructed by tutors in the basic humanist subjects, Luitpold took his Abitur examinations in 1908 before

4 Undated photograph of Duke Luitpold in Bavaria, about ten years old, with his dachshund

departing for Bamberg, where he did military service. He served as a lieutenant in the Royal Bavarian First Ulan Regiment under Kaiser Wilhelm II, to which his father, Maximilian Emanuel, had also belonged. Luitpold – like his father before him – was decorated with the medal of St Hubert.

From 1910 until the First World War broke out, Duke Luitpold studied philosophy and art history at Munich

university. His interests went far beyond the arts and humanities. Course registration sheets from the Ludwig-Maximilians-Universität archives show that he also attended lectures in chemistry, general science, economics, physics, the philosophy of art, world history, working-class and social movements as well as German constitutional history. He was also an avid fan of Richard Wagner's Ring of the Nibelungs. During the summer term of 1912, Luitpold attended lectures held by the celebrated art historian Heinrich Wölfflin, such as 'Albrecht Dürer', 'Art in the Age of Rubens and Rembrandt' and 'Renaissance Art in Italy and the Formation of Architectural Styles in the Middle Ages and the Early Modern Age with a Particular Focus on the Architectural History of Germany'. These lectures and his specialisation made Luitpold familiar with a wide spectrum ranging from Western medieval architecture to that of his own day.

At the same time, Luitpold 'trained systematically in painting', instructed by Friedrich Attenhuber, a painter thirteen years his senior, who was close to the Secessionist circles then regarded as progressive. Even at thirteen, Luitpold had shown interest in, and skill at, painting and drawing. At that early age, Luitpold decided to devote himself one day entirely to art. His artistic endeavours also occasionally found favour with the public. In 1913, Luitpold showed a work entitled Sicilian Coast at Brakl, a Munich art gallery. The gallery owner, Franz Josef Brakl, was closely allied with the 'Scholle' circle, the Neue Künstlervereinigung, the Blauer Reiter and the New Secession. A letter written to Attenhuber by the Duke on 7 January 1914 shows that he had sold pictures for 1000 marks, including a view of Garatshausen Palace on Lake Starnberg, which was also reproduced in the review Die Jugend.

The young Duke's extensive travels in the years before the First World War attest to his openmindedness and interest in art. On his many trips – on which he was sometimes accompanied by his painting instructor, Friedrich Attenhuber – Luitpold sought to broaden his 'insight into the art and cultural life of Europe and the Asian and African Mediterranean region'. Postcards, as well as photographs, attest to sojourns in Sicily and Egypt (1910) and in Toledo and Madrid (1912). During the winter of 1908/09, Luitpold embarked, together with Attenhuber, on a grand educational tour of Egypt, from which they returned via Tangier and Sicily.

During that time, Luitpold was also preparing his pet project, building a castle on the Ringberg, for which he had been buying property since 1911. Between 1911 and 1947, the Duke commissioned the painter Friedrich Attenhuber with extensive and manifold projects relating to the castle's realisation.

During the war years from 1914 to 1918, Duke Luitpold served on the Western Front. Soon promoted to first lieutenant and then to cavalry captain, and deployed in the Lorraine border region as well as in combat in Belgium and northern France, Luitpold – after a bout with serious illness – was transferred as an auxiliary intelligence officer

5 *Duke Luitpold aged fifteen, 1905*

His life

6 Duke Luitpold in Bavaria, Garatshausen Palace on Lake Starnberg. The Duke's painting was reproduced in the review Jugend in 1912.

in the capacity of Supreme Commander of the Armies, which evidently gave him time to devote himself intensively to the Ringberg project, albeit by from afar. Friedrich Attenhuber, with whom Luitpold engaged in a lively correspondence, was by now in charge of building activities, supervising the construction site, carrying out the Duke's written instructions and responding to his enquiries. To Luitpold, thinking about his building project represented a welcome distraction from what he was experiencing on the front. In a letter to Attenhuber dated 21 October 1915, Luitpold admitted: 'These discussions about building and instructions may perhaps get on your nerves, but to me they signify another, lost world and afford me recreation that you may not understand, for I hate the war.' Evidently, the castle being built for him, the 'sanctuary he dreamed of', was a refuge from the battle fields of the First World War. Luitpold intended to move into Ringberg Castle as soon as possible on his return home. But it never came to that. He never would become master of the house on the Ringberg – in the sense of residing in the castle.

In autumn 1919, the Duke resumed his studies, taking his doctorate under Heinrich Wölfflin in 1922. Luitpold wrote his dissertation in art history on the subject of 'Frankish Tapestries'; dealing with late medieval tapestries woven in the cities of Nuremberg, Bamberg and Eichstätt, it was published in Munich, by Kurt Wolff Verlag, in 1925.

In his foreword, Luitpold thanks everyone who had been helpful in furthering his dissertation, including 'Herr Attenhuber, painter, who drew my attention to the intrinsic value not only of German tapestries but also to tapestry weaving in its own right'.

Luitpold was receptive to everything new – sport, travel, scientific expeditions. When he was younger, he had been an enthusiastic hunter, was an outstanding, award-winning equestrian, a successful participant in international tennis tournaments and one of the earliest practitioners of skiing, then a sport in its infancy. In later years, his interest switched to hill-walking tours, on which he enjoyed expanding his excellent knowledge of botany. In the meantime, he lived in the city, spent time at rela-

7 *Friedrich Attenhuber, Duke Luitpold Reading, oil painting, c. 1920*

8 This Neoclassical building, the New Biederstein Palace in Munich's Schwabing district, was owned by Duke Luitpold and demolished after he sold it in 1934.

tives' homes, was restless and often on his way to somewhere or other. His life was also shaped by the role he had assumed as the builder of a castle, or a castle complex, and he would sustain that role for the rest of his life. Only occasionally, in the late 1920s and during the Second World War, did the Duke actually live in his castle.

Luitpold had sunk practically his entire fortune into the Ringberg. Financial straits, especially in the early 1920s and during the Depression years, forced him to give up Biederstein Palace in Schwabing, which he had inherited from his father. Today nothing is left of that family estate. Biederstein Palace had been owned by the Wittelsbachs since 1802. Maximilian I Joseph, who would later become king of Bavaria, acquired it and gave it to his wife, Karoline. From 1825, it was where she resided as the widowed queen. Through her daughter, Ludovika, to whom Karoline bequeathed Biederstein Palace in 1841, it came into the possession of the Dukes in Bavaria. In 1876, Ludovika gave it to her youngest son, Max Emanuel, who was Luitpold's father. In 1934, the New Palace was torn down. The Old Palace was then demolished after sustaining bomb damage in the Second World War. Most of the Biederstein inventory went under the hammer in 1930. Much of the auctioned lots ended up in Munich's Stadtmuseum and in the possession of the Princes of Thurn and Taxis.

Duke Luitpold continued to drive his building project forwards even in the era of the National Socialist regime, times that were also uncertain and threatening for the Wittelsbach family. The Wittelsbachs, who were persecuted by the National Socialists, were not permitted to serve in the military. Several members of the royal line were interned in concentration camps. Luitpold's cousin, Ludwig Wilhelm in Bavaria, who had been head of the line since 1909, had emigrated in 1938. Duke Luitpold was forced to sell Possenhofen Palace on Lake Starnberg to the National Socialist Social Welfare Authority in 1943, which entrusted it to the Luftwaffe as a facility for training med-

cousin, Ludwig Wilhelm. The Duke bore the Palatinate Wittelsbach coat of arms. They display in a quartered escutcheon the Palatinate lion in the first and fourth fields and the white-and-blue Bavarian lozenges in the second and third. As his motto, Luitpold chose, like the Palgrave Ottheinrich before him, 'With the times' – an anachronism indeed for a man who commissioned a medieval fortified castle in the 20th century.

Luitpold's last place of residence was the sanatorium in Kreuth. Until the very end, he was preoccupied with the future of Ringberg Castle. He would die without issue and his relatives had no interest in taking over the construction site. Both the parish of Kreuth and the city of Munich rejected his offer of it because they feared the heavy subsequent financial burden and the high cost of its upkeep. Finally, the Max Planck Society was willing to take it over after the Duke had also agreed to bequeath his considerable private fortune for the upkeep of the castle and grounds.

Luitpold died on 16 January 1973, the last direct descendant of the Dukes in Bavaria. He had decided on an

9 Duke Luitpold on horseback in front of Possenhofen Palace, undated photograph. In the 1930s he inherited this estate, which remained in his possession until 1943/44.

ical orderlies. The State of Bavaria took it over in 1945. Luitpold waived the right of repurchasing it, probably because the property was in such poor condition.

Immediately after the Second World War, Luitpold resumed construction work on Ringberg Castle. In the last twenty years of his life, he had himself driven to Ringberg Castle almost daily from Munich, where he lodged at the Four Seasons Hotel. The architects in his employ at that time, Max Berger and Heinz Schilling, described the Duke as a patron who had clearly formulated ideas of what he wanted and who was able to convey to his architects what he specifically had in mind. Schilling went so far as to characterise Luitpold as a 'peerless' patron, who made possible an 'ideal relationship between patron and architect'. Mention should, however, be made of the fact that Luitpold was not on such an easy footing with the Building and Planning authorities.

In 1968, Luitpold temporarily became head of the collateral line of the House of Wittelsbach on the death of his

10 Friedrich Attenhuber, Duke Luitpold in Bavaria, oil painting, 1943

His life

11 Friedrich Attenhuber, Duke Luitpold in Bavaria against the Backdrop of the Kreuth Valley South of Ringberg Castle, oil painting, 1944

The royal patron – Duke Luitpold in Bavaria

urn grave, an unusual choice among the Wittelsbachs and quite incomprehensible to them. His urn is buried near the chapel on the Ringberg.

Luitpold could never decide on marrying. Over the years, his friendship with the older painter Friedrich Attenhuber became increasingly awkward, indeed strained. Symbolically anticipatory, the mural in the stairwell of his castle depicts Luitpold in front of a dead tree, accompanied by his cousin Ludwig Wilhelm. Empress Elisabeth of Austria, Luitpold's aunt, had spoken forebodingly of the extinction of that – her own – line: she had had a vision, in which the legendary monk of Tegernsee, whose accursed soul would be redeemed only with that of the last of the ducal line in Bavaria, had allegedly prophesied to her that her line would be extinct before the lapse of a century.

FAMILY BACKGROUND

The fraught relationship between the principal and the collateral line of the Wittelsbachs lasted for centuries and represented a crucial underlying reason for building the castle on the Ringberg. Duke Luitpold belonged to the Wittelsbach line of the Palgraves of Birkenfeld-Gelnhausen, which, after three centuries, became extinct on his death. It is one of the collateral lines of the Palatinate Wittelsbachs from the House of Zweibrücken. The common ancestor of the two lines was Wolfgang I, Palgrave of Zweibrücken (1526–1569). As the viceroy of the Upper Palatinate (1551–1556), he was the political link with Ottheinrich, the Elector Palatine.

The Birkenfeld-Bischweiler line split into two: the Birkenfeld-Bischweiler-Rappoltstein line (with the Zweibrücken succession from 1731), which was raised to Electoral status in 1799 and from 1806 bore the title of kings, and the Birkenfeld-Gelnhausen line, which from 1799 bore the title 'Dukes in Bavaria'. The title was secured by Wilhelm of Birkenfeld (1752–1837), who always strove to ensure the equality of his line with that of Zweibrücken by practising an adroit policy within the family.

The marriage of Duke Luitpold's grandparents, Duke Max in Bavaria to Ludovika of Bavaria, again created a direct link between the 'royal' Birkenfeld principal line and the ducal collateral line, which induced Ludwig I to emphasise clearly the difference in rank between his royal line and the ducal collateral line by insisting on the correct use of the titles.

The nuptials of Max and Ludovika took place in the castle church at Tegernsee on 9 September 1828; thus the focus of the family history moved to the place where Ringberg Castle would later be built. When Ludovika's legacy passed to her son, Karl Theodor, in 1876, the royal domains in Tegernsee went from the reigning Wittelsbach line to the ducal line in Bavaria. Ringberg Castle is the last architectural testimony to that collateral line, which had struggled so hard to maintain its position against the principal line. Indeed, it marks the last attempt made by the collateral line to erect a monument to itself, perhaps even to establish a family seat of sorts.

12 Ringberg Castle. The alcove near the chapel with the urn containing the ashes of Luitpold, Duke in Bavaria, who died on 16 January 1973

The 'court artist' – Friedrich Attenhuber

Friedrich Attenhuber played the role of the last Wittelsbach 'court artist'. He worked solely for his patron, Duke Luitpold in Bavaria, for thirty-five years. Attenhuber not only designed and planned the castle on the Ringberg at Tegernsee, but also organised the project and supervised its construction. Over that long period, he devoted his talents to that complex building project and put his creative powers and his freedom entirely at the Duke's service. His signature on the building project survived his death – from the architectural design on down to the last detail of the furnishings and appointments.

Before committing himself to Ringberg Castle, Attenhuber had embarked on a more than respectable career as a painter, although his name would be sought in vain in specialist publications (except for a short entry in Thieme and Becker's Allgemeines Lexikon der bildenden Künstler). Who was Friedrich Attenhuber, that artist 'whose beginnings seemed to justify the greatest expectations and who then vanished without trace'? (A statement made by Fritz Erler, painter and founder-member of the group of artists known as the 'Scholle' [Soil], to Duke Luitpold and quoted in a letter of Luitpold's dated 21 January 1918)

STAGES IN THE ARTIST'S LIFE

Friedrich Attenhuber came from a poor, working-class background. Sources containing information on his family and his early life are few and far between.

Attenhuber was born in Burghausen an der Salzach on 19 February 1877. The parish registry names his mother as Sofie Rahn, the daughter of a weaver from Arzberg in the Fichtelgebirge, Protestant, spinster. In 1879, Sofie Rahn is recorded as an unmarried worker in an Augsburg factory. Johann Attenhuber, Sergeant, of Altenmarkt, Traunstein district, Catholic, bachelor, is listed as the father of her son Christian, born that same year. The name Attenhuber first appears in Munich's municipal address book in 1881. The following year, Johann Attenhuber and Sofie Rahn married. Friedrich and his brother, who was two years younger, were declared legitimate; a daughter, Maria, was born later. Friedrich grew up with his younger brother and sister near the Theresienwiese in Schiessstättstrasse on the Schwanthalerhöhe, a traditional Munich working-class district. His father died in 1928. In the death notice, he is honoured as a 'veteran of 70/71'. Further, the death notice reveals that he started as a batman and rose to section commander.

In 1898, Friedrich Attenhuber, now twenty-one years old, began to study painting at the Bavarian Academy of Fine Art. Presumably he had already completed a course

13 Friedrich Attenhuber, Self-portrait of the Artist as a Young Man, presumably executed before he trained as a painter, charcoal drawing, before 1900

of vocational training in lithography and financed his further studies by taking on print-making commissions.

Two events attest to the young painter's qualifications and artistic independence, both of them linked with Berlin, the imperial capital: an invitation to show work at the 1904 Berlin Secession exhibition and a contract, dated 1907, confirming that he had collaborated on paintings for the Reichstag Building.

Friedrich Attenhuber appears for the first time in Munich's municipal address book of 1907, with his profession given as painter. Two years later, he had a studio of his own in Mozartstrasse. The fact that this studio was in the upper-middle class and aristocratic residential section east of the Theresienwiese indicates a new phase in the artist's life, which was evidently marked by a degree of upward mobility.

By 1907/08, Friedrich Attenhuber had already made the acquaintance of Luitpold, Duke in Bavaria. Around the age of thirty, Attenhuber was introduced as a painting instructor to the Wittelsbach Duke, allegedly as a member of the master class taught by Ludwig von Herterich, his Academy teacher. His contact with Luitpold intensified around 1910, when Attenhuber accompanied the Wittelsbach Duke, who was thirteen years his junior, not only to his studies at Munich University but also on several trips to the traditional art centres in southern Europe as well as to the Near East and North Africa. At the same time, he familiarised himself as a painting instructor with the estates owned by the Wittelsbach collateral line on Lake Starnberg and Tegernsee, one of the places where Luitpold grew up. Attenhuber was a regular visitor to Biederstein Palace in Munich's Schwabing district, where the Duke then resided, and used the extensive library there with its specialist publications on art and art history.

Although a painter, Attenhuber worked out the plans for the young Duke's 'Florentine villa and grounds', on which building was to commence in 1911/12, when it was called 'Ringberg Castle'. Even if the First World War interrupted the planning stage of the castle and construction work on it ceased, Attenhuber continued to work on the project, albeit now on designs for the furnishings and appointments. At that time, Attenhuber was still independent, living and painting in Munich and on Chiemsee with the artists' colony there. With Luitpold, who had been in combat since the outbreak of the First World War, Attenhuber maintained an intensive correspondence until he himself was called up early in 1917.

After serving nearly two years as an army engineer in a surveying unit, primarily in northern France, Friedrich Attenhuber was discharged from the military at the age of forty-one, on 27 November 1918 – with 50 marks severance pay and 15 marks marching money. Conditions were as bad as they could be for picking up the loose ends of the career in art he had tentatively embarked on before the Great War.

After the war, Attenhuber resumed his collaboration with his 'friend', Duke Luitpold. His duties at Ringberg Castle were by now no longer confined to designing furnishings and appointments. Attenhuber moved on to overseeing their production, functioning also as an architect and a supervisor. Even after the interior design and the furnishings had been completed in essentials during the 1920s and severe tensions and disagreements had grown up between the artist and his patron, it was impossible for the painter, who was no longer young, as his life's work. In 1930, Attenhuber gave up his Munich studio to live at the Ringberg. Owing to financial, political and personal reasons, his mobility became increasingly limited. As he grew older, he suffered excruciatingly from his isolation. Atten-

14 Friedrich Attenhuber, photograph, c. 1910

huber's energies had been drained. Looking back over his life, he had to admit that he had sacrificed his best years exclusively to a patron who was, after all, inconsistent in the extreme and to work that was accordingly contradictory in nature so that both his development as an artist and as a man had ended in a cul-de-sac. He had not dared continue his career as a freelance painter. It had not escaped his notice that Munich's reputation as a 'city of art' had exerted an enormous pull on far too many artists, whose economic situation had already begun to deteriorate before the First World War.

He had had, on the contrary, in the opportunity of collaborating on a 'total work of art' on the Ringberg, the prospect of an extraordinarily sophisticated aesthetic mission; at the same time, his livelihood had seemed to be secured by it. The whole thing, however, ended in a tragic dependence. Contemporaries of Friedrich – also known as Fritz – Attenhuber's described him as 'shy' and 'self-effacing' yet, on the other hand, as a 'gentleman', 'a fine person who let himself be used'. Photographs and paintings show him in early adulthood as a tall, commanding man but, in old age, dressed like a monk, he looks somewhat haggard and taciturn.

Attenhuber died on 7 December 1947. He had jumped from the castle tower. His grave in the Egern cemetery is now left untended. Only a memorial stone in the wood outside the curtain wall at Ringberg Castle commemorates him. Virtually nothing is known about him as a person other than his life's work, the castle and its interior, paintings, sculpture, drawings and photographs. Almost all his work, including his early paintings, is at Ringberg Castle and is owned by the Max Planck Society.

FRIEDRICH ATTENHUBER'S PATH TO BECOMING 'A MATURE ADEPT AND AN INDEPENDENT ARTIST'

Friedrich Attenhuber's career as a painter began in April 1898, when he started his studies at the Academy of Fine Art in Munich. Then only twenty-one, Attenhuber at first enrolled in Paul Höcker's painting classes, but he continued his training primarily under the tutelage of Ludwig von Herterich; Attenhuber is thought to have served an apprenticeship under Ludwig Schmid-Reutte before his Academy years. Attenhuber's choice of instructors provides information on the grounding, the orientation and the possibilities open to him in his artistic career and points directly to the aesthetic and cultural background of the environment in which he trained, that is, the Munich Secession.

> ### The Munich Secession
>
> 'Secession' is the term used for the separatist artists' groups adopted by progressively minded artists in Germany and Austria towards the close of the 19th century. This schism with the existing artists' organisations grew out of a protest against the traditionalism promoted by the state and the Academy. Members of the new organisation wanted to create a cultural-political forum for themselves in order to ensure that they were solely responsible for setting objective standards for choosing the art to be promoted. The Munich Secession marked the beginning of this separatist movement. On 4 April 1892, some one hundred artists left the privileged artists' co-operative dominated by Franz von Lenbach, the prince of painters, to found a separatist fine-arts association of their own called he Secession. This alliance of artists strove to form a counterweight to the establishment. Its members did not advocate any particular style; rather their agenda was as much freedom as possible and the individual's right to decide on his or her own style. This association soon split into several factions; other Secessions were founded, in Vienna (1897), in Berlin (1898) and in Darmstadt (1919).

Attenhuber's instructor at the Academy, Paul Höcker, played a major role in founding the Munich Secession in 1892. From his classes came the first staff of the review *Jugend. Münchner illustrierte Zeitschrift für Kunst und Leben*, which appeared from 1896, and, more to the point, many members of the artists' association known as the 'Scholle', which was founded in 1899.

Ludwig von Herterich, another Munich Academy professor, also belonged to the first generation of Secessionists. Herterich was familiar with the Munich tradition of painting in the grand style, yet he painted in a style that marked the transition from the 1870s Wilhelmine boom-years style to Impressionism and Art Nouveau. Typical of Herterich was his striving for a realistic view of nature and

15 *Friedrich Attenhuber, Self-portrait of the Artist at his Easel, oil painting, c. 1914*

open-air painting by means of a simple, generous handling of forms that tended towards monumentality. Another exponent of the monumental style was Ludwig Schmid-Reutte, who taught Attenhuber before his Academy days. Under the sway of Ferdinand Hodler, Schmid-Reutte created compositions of hierarchical stringency and almost Cubist monumentality.

According to a recommendation written by Professor Arthur Rümann, Attenhuber had acquired from Schmid-Reutte the 'fundamentals of drawing with assurance and composition conceived on a grand scale' before following 'in his palette the doctrines of his master, Paul Höcker', who taught under the auspices of the artists' association called the 'Scholle' (Soil). During his years with Ludwig von Herterich, Attenhuber attained a psychologically more sophisticated handling of colour; his figurative compositions loosened up and came into their own 'so that Attenhuber left the Art Academy as a mature adept and an independent artist'. (director of the Städtische Kunstsammlungen, Städtische Galerie and Lenbachgalerie, 26 October 1953)

Any contacts Attenhuber succeeded in making with the official art scene after his time at the Academy ended came through the instructors he had chosen there. Not long after training at Munich's Academy of Fine Art, Friedrich Attenhuber, now twenty-seven years old, forged an important link with Berlin. In February 1904, Max Liebermann wrote in his capacity as president of the Berlin Secession to Attenhuber in Munich: 'Dear Sir, With respectful reference to the agreement reached between you and Herr Corinth, we request that you entrust with us your works *Deminude, The Mocking of Christ, Nude Study* … for our exhibition.' The contact with Corinth may have come about in connection with Jugend or Simplizissimus magazines, or when Attenhuber presumably stayed at the New Dachau artists' colony. Friedrich Attenhuber also showed two paintings, a reclining male nude and a seated deminude study of an old man, at that Berlin exhibition in 1904, which was devoted entirely to the Munich Secession. In a rather caustic commentary on the exhibition published in the periodical Kunst für Alle, the Berlin art critic Hans Rosenhagen had little time for the Munich display in general and even found something disparaging to say about Attenhuber: 'A pupil of his [Ludwig von Herterich's], Friedrich Attenhuber, showed off with a reclining male nude and a seated deminude of an old man, works in which he tries to achieve painterly effects with the same affected means as those of his teacher, which have nothing at all to do with painting itself and are the very opposite of conscientious study. It is impossible to say whether Attenhuber has talent.'

A contract dated 23 August 1907 verifies that Friedrich Attenhuber collaborated on the history paintings for the Plenary Sessions Hall in the Berlin Reichstag building: 'Herr Fritz Attenhuber, painter, is helping Professor Angelo Jank in executing the paintings for the Plenary Sessions Hall in the Reichstag building … Work commenced on 2 July 1907.' No pictures document Attenhuber's work in the Reichstag or his participation in the 1904 Berlin Secession exhibition. The three large history paintings by Angelo Jank, a Secessionist, were hung in November 1908; however, when members of all Reichstag parties objected to them for various reasons, they were taken down again early in 1909. The incident made the annals of art history as the 'Jank Affair'. Nevertheless, his participation in the exhibition and the important commission in the imperial capital suggest that Attenhuber was well on his way to making a name for himself in the art scene.

Friedrich Attenhuber worked in a peculiarly south German style within the German Impressionist tradition as represented by the 'Scholle'. His work is best classified as resembling that of the painter Leo Putz. Attenhuber's

16 *Angelo Jank, handwritten contract 23 August 1907. The Academy professor confirmed that Friedrich Attenhuber collaborated on the history paintings for the Plenary Sessions Hall in the Berlin Reichstag building.*

The 'court artist' – Friedrich Attenhuber

17 Friedrich Attenhuber, Portrait of a Young Lady, oil painting, c. 1914

handling is similar to Putz's, as is his choice of subject matter. However, it is occasionally apparent that, unlike Putz, Attenhuber did not come from a cultivated upper-middle-class background; he lacked the assurance characteristic of that class and his choice of models did not conform to upper-class standards. Attenhuber's portrayals of women reveal that they were from humble backgrounds rather than a comfortably bourgeois milieu: servants, peas-

Friedrich Attenhuber's Path ...

18 Friedrich Attenhuber, Girl Looking down into a Garden from a Balcony, oil painting, c.1920

> ### The 'Scholle'
>
> In 1899, a group of painters, most of them working in Munich, formed an association called the 'Scholle' (Soil). The twelve active members came from the Munich Secession, from the circle who worked for the review Der Jugend or attended the painting classes taught by Paul Höcker at the Munich Academy. Among the members of the group were Fritz Erler, Gustav Bechler, Reinhold Max Eichler, Erich Erler-Samaden, Max Feldbauer, Walter Georgi, Adolf Höfer, Adolf Münzer, Robert Weise and Leo Putz. The name the 'Scholle' encapsulates the group's individualistic agenda, which was that every artist in the association develop his or her abilities as one 'ploughs one's own furrow' and 'that everyone works his own soil, which, admittedly, cannot be found on any map'. For all the artistic licence permitted, these artists represented the neo-idealistic trend of uniting art, nature and life in the sense of a modern natural lyricism and distilling them into allegorical pictures. In so doing, they adopted the stylistic devices of a decorative Impressionism, of Art Nouveau, the new poster art and Symbolism, and transformed them. Rejecting Academic criteria, and classified in Munich as Lenbach's 'brown painting', these pictures demonstrate a flat, almost poster-like style featuring stark colour contrasts. Many of these artists worked outdoors and even went to live with artists of their acquaintance in the Ammersee region, to Chiemsee or Dachau. Through their involvement in the great art shows mounted by the Viennese, the Berlin and the Munich Secessions, the 'Scholle' painters contributed to the changes occurring in art as the fin de siècle drew to a close.

ant girls, the wife of the ducal valet, with the occasional aristocratic woman only as the exception to the rule. As far as Attenhuber's artistic interpretation went, his representations are immediate, earthy, not smooth or idealised, even though he was concerned with elevating his models by ennobling them in his pictures. A comparison with the photographic studies from which he worked reveals this stance. Here, Attenhuber's approach is revealed: he worked from photographs that he had taken himself; the photographic frame, the photographic snapshot, went right into his works. That places him in the tradition of painters who used this technique at an early date.

Compared to his teachers and contemporaries, Attenhuber was a modern painter, who in his pictures skilfully interpreted the fundamentals and paradigms of the post-Impressionist training he had received and enlarged on them. He was modern but not avant-garde. A pronounced capacity for attaining decorative effects matched a stylistically formative conception of art that paid allegiance to Art Nouveau (called 'Jugendstil' in German) as developed in the review Die Jugend from 1896 and which attained a high standard in the new poster art. Attenhuber composed his pictures spaciously and dynamically, painted in vivid colours and had no qualms about using candidly framed photographs. Despite his penchant for flat surface treatment, he never – unlike the Expressionists, who were already experimenting – eschewed perspective entirely in his handling of the subject matter. The pictures of his that look most 'modern' are those that reveal the direct influence of Gauguin or Matisse. Attenhuber may have seen their work in Berlin or Munich. Essentially, however, he remained committed to a post-Impressionist conception of painting ('I am a pupil of Herterich's') even though he, like Hodler, enlarged its scope to encompass a tendency towards figures on a large scale. Attenhuber painted at

19 Friedrich Attenhuber posing as the Crucified Christ, photographed in his studio with a self-timer, c. 1910

20 Friedrich Attenhuber, Lady in a Boat by a Lake Shore, oil painting, c. 1914

Chiemsee, where the earliest artists' colonies had sprung up by the first half of the 19th century. Presumably, he also had contact with the colonies in Dachau and Wessling.

ATTENHUBER AS THE ALL-ROUND ARTIST ON THE RINGBERG

The inception of the new building project on the Ringberg opened up an entirely new field of activity for Friedrich Attenhuber, who had hitherto only painted; until then he had had no experience of architecture, sculpture or the decorative and applied arts. He took on the challenge,

21 Friedrich Attenhuber, lady in a boat by a lake shore, photograph, c. 1914, photographic study for the painting displayed above 1914

The 'court artist' – Friedrich Attenhuber

22 *Friedrich Attenhuber, Couple Dancing, oil painting, c. 1910*

chiefly to secure a livelihood for the present at least – and this at a time that was very difficult for artists. Another reason for venturing on this risky enterprise was presumably the prestige he might reasonably have expected to accrue to him from it because the workshop movement (p. 90) had ensured that due respect was paid to all creative activities – whether arts or crafts – that contributed to the conscious design of the living environment. To handle this commission, Attenhuber had left behind big-city life to work in the seclusion of the Ringberg.

Attenhuber as the all-round artist on the Ringberg

23 Friedrich Attenhuber, Chiemsee Landscape, oil painting, c. 1914

For the Duke, Attenhuber switched from the role he had played up to then as his private painting instructor to the status of his 'private artist'. By 1915, Luitpold was urging Attenhuber into move to the castle 'when the house is in a state to be lived in'. Although Attenhuber had briefly concentrated on working on Ringberg Castle and its appointments before and while the shell was going up, he still found quite a bit of time for his own work. From about 1922, he lived at Ringberg Castle, where by then two studio rooms had been made available to him for his work – one in the stairwell turret of the main building and the other on the second floor of the Guest Tower. Those rooms, however, represented a temporary arrangement and were without all amenities. Rumour had it that Attenhuber was 'housed' there.

Friedrich Attenhuber's function consisted in advising in all art-related issues on the construction site and commissioning work to be done. During the thirty-five years or more of his work as Luitpold's 'personal artist', he never stopped making sketches and drawing up plans. He devel-

24 Friedrich Attenhuber, Self-portrait, red chalk drawing, c. 1914

The 'court artist' – Friedrich Attenhuber

25 Ringberg Castle. Friedrich Attenhuber's studio in the Guest Tower, 1981

oped the preliminary designs for the main building, that is, the façades and ground plans, as well as such details as the vertical portal jambs, the portal architraves and doors and the plans, which were then submitted to Heilmann & Littmann, a construction firm, for approval. It was Attenhuber who drew up the plans for the tower – which, while still in the planning phase, was made higher to accommodate guest rooms – for the chapel, for the entrance tower with the adjoining annexe, for the Summer House with the abutting chemin-de-ronde, for the south tower, for converting the belvedere into an observation tower, for the crenellated south ramparts and the pergola on the south terrace. Moreover, in the 1920s, he made sketches and drafted plans for numerous envisaged projects. He designed and developed all the fixtures as well as the movable furnishings and appointments for the main building.

Attenhuber had to explain in person his detailed drawings as well as the choice and quality of materials to the craftsmen and to ensure work was carried out properly. Finally, his duties that were 'unrelated to art' should not be overlooked: after all, he also took on the role of building supervisor as well as intermediary between the Duke's ideas and wishes and the construction firms carrying out the work and he obtained and compared cost estimates and checked invoices submitted for work actually done. The Duke also entrusted Attenhuber with organising furniture transport – probably a difficult task when considering how inaccessible the site on the Ringberg was at the time. Some objects could be transported only with the aid of a span of mules. His duties also included supervising the arrangement of the furniture and all appointments, organising large-scale transports of stone and wood, meticulously checking materials on delivery and in general supervising all construction activity. He also had to deal with works of sculpture in all sorts of materials: in stone – for instance, for the fountain in the inner courtyard – in bronze and even in wood.

Practising the profession he had learnt, Attenhuber executed the paintings, murals and, in the wider context, also the designs for tapestries that were to be made on

26 Topping-out ceremony on the Ringberg, on 26 September 1913: Duke Luitpold can be seen in the centre and Friedrich Attenhuber on his left (wearing hat and coat)

commission for Duke Luitpold. In the tapestry designs, especially the witches' cycle, Attenhuber's talent as a colourist and his gift for composition come into their own. These works, however, reveal no trace of the style of Attenhuber's early work 'under the sway of Scholle painting'. Presumably, the pictures for the castle rooms were done according to his patron's wishes and this goes particularly for the subject matter, which had to be changed several times on the Duke's instructions. In the 1920s, Attenhuber chose an expressive palette for his paintings that featured some garish colours.

The mural in the stairwell at Ringberg Castle exemplifies the problems Attenhuber had with the paintings. While Ludwig Wilhelm appears like the sportsman he was in huntsman's dress with gun, walking stick and a hunting dog at his side, Luitpold looks rather affected, like an urbanite on summer holiday. Behind Luitpold stands a dead tree. This is an allusion to a prophesy made by the Empress Elisabeth of Austria that the ducal line in Bavaria would die out. The palette of the painting looks vivid, even lurid – as in many later Attenhuber canvases. In a photo on which the painting is based, the men can be seen posing stiffly. Luitpold had corrections done to the picture more than once: 'Just change the foreground and the valley with the meadow and the lake enough for me – do not leave anything superficial, anything indeterminate or off-colour in the picture – astringent, clear, resolutely constructed … I certainly find it hard to make anything significant of you;

The 'court artist' – Friedrich Attenhuber

today I am thirty-seven years old and you still need my advice.' The Duke had also instructed Attenhuber to change the picture because Ludwig Wilhelm, who outranked the Duke, was not represented on the appropriate scale.

Attenhuber's personal development as an artist continued to slow down during his years at the Ringberg, coming to a standstill as an anaemic vernacular style watered down by aesthetic revisionism. The paintings he did in the 1930s and '40s, the works that belong to the original interior design of Ringberg Castle, are informed by a disconcertingly naturalistic style. Spontaneous expression has been replaced by photographic precision, all movement has congealed into pose, the palette of these paintings has become garish and even loud and the motifs are imbued with a neo-Romantic histrionic pathos. Motifs from Greco-Roman mythology are occasionally introduced into these

27 *Ludwig Wilhelm (left) and Luitpold (right), Dukes in Bavaria, undated photograph on which the mural in the main stairwell was based*

28 *Desiccated tree, undated photographic study for the mural in the main stairwell*

paintings alongside 'earthy, patriotic' scenes reeking of the Wandervogel movement or rural vernacular Romanticism. In addition, Attenhuber produced numerous portraits of local residents as well as animal and plant pictures executed in a conservative 'Old Master' style. Evaluating this body of work is not as simple as it might seem. Calling it 'blood and soil art' would mean mislabelling it, because the artist and his patron were definitely far removed from that Third Reich style. The way art developed in the 20th century – the path many artists took who were still decidedly modern in bias before the First World War – has yet to be studied in depth and many questions remain unanswered.

THE RELATIONSHIP BETWEEN ARTIST AND PATRON

The relationship between Luitpold, Duke in Bavaria, and Friedrich Attenhuber was shaped both by the very different conditions imposed by their social backgrounds and education and the different roles assigned to them in society.

Duke Luitpold was initially the pupil and Attenhuber, who was thirteen years his senior, was his private instruc-

19

LVDWIG WILH VND LVITPOLD HERZOGE IN BAYERN

29 Friedrich Attenhuber's mural in the main stairwell of Ringberg Castle, secco technique, 1926. The painting illustrates the moment as Duke Luitpold (right) and his cousin Ludwig Wilhelm in Bavaria spotted the site on the Ringberg.

30 Friedrich Attenhuber, oil painting belonging to the painting cycle in the 'Spring Room', 1931

tor. The realities of life for both could scarcely be more disparate: one was rich, the other poor. One was a member of the aristocracy, who had a wide range of educational opportunities available to him; the other was of working-class origins and born out of wedlock. Growing up in a lower middle-class environment, he had to struggle to receive the art training he did.

31 Friedrich Attenhuber, Pastoral Scene, small-format oil painting, undated

The 'court artist' – Friedrich Attenhuber

The social disparity seemed unimportant when the Duke, at seventeen, with his secondary school certificate in his pocket and his aesthetic interests, encountered the thirty-year-old painter with his professional Academy training, a hard-working man whose talent augured well, and who had an early record of exhibitions, commissions and contact with distinguished artists.

A friendship grew out of the pupil-teacher relationship, as a letter written by the Duke to Attenhuber's mother confirms. (fig. 32) The castle project on the Ringberg emerged from common interests and ideas, inspired by their travels together, notably an art trip to Florence. The upshot of the Ringberg project was, of course, that the role played by the young Duke widened in scope. He was, after all, the patron commissioning and paying for the project. By the outbreak of the First World War, a shell stood on the Ringberg. As the years passed, and this is clear from in his correspondence with Attenhuber, the Duke, shaken by the events on the Western Front, became obsessed with the castle. On the one hand, it became a chimerical vision and refuge; on the other, it furnished him with a concrete prospect: 'And after the war years, one will be even happier to have a quiet place that is rather remote ...' (letter of 13 August 1918). Attenhuber was still freelancing at the time. He painted on Chiemsee or stayed at Tegernsee and on the Ringberg. From a distance, the Duke bombarded him with ideas, thoughts on the construction of the castle and especially on its furnishings and appointments. He asked Attenhuber for his opinion, commented on his suggestions, asked him to perform specified tasks. Luitpold seems to have been good to Attenhuber, who is said to have received a 'very generous provision in case something happened to HRH' when the Duke was sent to the front at the commencement of hostilities in the Great War.

In questions directly related to the project, a tone of partnership and respect informed the ducal dispatches. The tone changed after the war. By his own efforts, Luitpold attained new status: that of an art historian with a doctorate. The language in his letters and notes became more commanding, self-assured and cool. He was the patron and wished to take up residence as soon as possible at Ringberg Castle. It no longer seemed necessary to treat Attenhuber as someone 'of his own age' as Luitpold was still doing in 1917: 'Whenever I sat down with you at a meal or afterwards, I had the feeling we were of the same age'

(letter of 18 November 1917). The Duke was now in a position to exercise patronage and he had the presumption to reproach Attenhuber with indolence – a trait he had merely ironically derided earlier. Luitpold continually accused Attenhuber of deliberately delaying completion of the house because all he had to do was 'his art work'. Attenhuber countered that he was not just acting in the capacity of an interior decorator, but indeed had to cope with all on-site construction work, however tiresome it might be, on down to simple caretaking tasks; he himself called it 'day-labourer drudgery'. The Duke for his part had to struggle with funding problems. He sold Biederstein Palace and had its furnishings auctioned off. He, too, was affected by the Depression. Attenhuber in turn complained in a desperate letter written to Ludwig Wilhelm, head of Luitpold's line, of the wretched circumstances in which he was forced to live. And from then on Attenhuber's situation deteriorated; from then, at the latest, he should have stood up for his own interests. He was unable

32 Letter written by Duke Luitpold to Friedrich Attenhuber's mother on 23 December 1917

The relationship between artist and patron

33 Duke Luitpold on his travels, presumably photographed by Friedrich Attenhuber, who accompanied him in 1908/09

to do that: personal timidity, inflexibility, poverty and what can only be called masochistic personality traits must have induced the artist to stay on at the Ringberg. Now that Attenhuber was over fifty, his prospects were dreary indeed. The Third Reich put paid to all chances of a fresh beginning. At that point, Attenhuber's life took a tragic turn. The Duke, by contrast, always restless and going somewhere or other, was no longer really interested in living on the Ringberg, evidently influenced by the political changes wrought by the Third Reich. Nevertheless, he continued to shape further developments at a distance by giving commissions, querying and urging. And he saw to it that Attenhuber would not be able to break away from the counter-world on the Ringberg to which he had once committed himself with such dedication.

Everything had begun so promisingly for Attenhuber. Looked at from the standpoint of earning the necessary livelihood, the offer of a post as painting instructor to the Wittelsbach Duke must have seemed a more than welcome opportunity. Besides the financial remuneration, it opened up entirely new possibilities: access to loftier social circles, to more diverse forms of further education and to greater mobility as the Duke's travelling companion. It went without saying that Luitpold forged and maintained links with the leading Munich art dealers, verifiably so with Lehman Bernheimer and Brakls Moderner Kunsthandlung, through whom Attenhuber may even have come into contact with the 'Scholle' painter Leo Putz. Attenhuber also shared in the Duke's art-history studies at Munich University. At Heinrich Wölfflin's lectures, 'everyone in Munich gathered; the young people listened to him with bated breath'. Even Attenhuber must have been impressed, as a very personal statement of his reveals, in which the later conflicts with the Duke already show up in vivid outlines: 'Should Wölfflin come sometime, I would speak to him only about whether hatred or love can engender more creativity' (undated note of Attenhuber's, probably mid-1920s).

The commission to build a castle for a friend in a reciprocal process of joint activity, a building of an unprecedented kind, meant a unique challenge and an opportunity for Attenhuber.

Although Attenhuber lacked the educational background for some of the tasks with which he was entrusted, Luitpold made up for it with his vast store of knowledge.

The dissertation of Duke Luitpold on 'Franconian Tapestries' reveals him to be knowledgeable about art. For his tapestry designs, Attenhuber drew freely on his

patron's specialist knowledge of medieval iconographic programmes and iconography in general. The mythological subject matter featuring in the paintings 'commissioned' for Ringberg Castle, on the other hand, probably emerged from the Duke's intellectual orientation and educational horizons.

The Duke was concerned with creating a link between art and nature at his castle above Tegernsee. It was premised on his love of art, in which his friendship with Attenhuber was also grounded. At the new construction site on the Ringberg, Attenhuber now also had to adjust his intellectual compass to the extremes of urbanity – nature – yearnings for faraway places. He had close ties to the metropolis as the centre of new art movements and developments in art: the Secessions, Art Nouveau and the neo-Impressionism espoused by the 'Scholle' had been the formative influences that shaped his years of study and training. At the same time, he experienced at first hand how those art movements also had a pronounced escapist element about them, something between hostility to all things urban and neo-Romanticism. Groups of artists went to the country to avoid the civilisation they so feared. 'A romantic attitude to travel sprang up everywhere, which stood in sharp contrast to the urban hedonism of Impressionism.' (R. Hamann and J. Hermand, Stilkunst um 1900, Berlin 1967)

Attenhuber also developed the mannerisms and posturings of a dandy, which are clearly apparent in some of his self-portraits. As a dandy, he enjoyed toying with aristocratic gestures; the Duke was, of course, an aristocrat. If he was fed up with the city and sought proximity to nature, he had his family's country estates at his disposal. He enjoyed shooting, a sport that to him represented a perfectly natural, historically founded prerogative. Hunting motifs consequently played an important role in the first phase of decorating his castle on the Ringberg. Motifs taken from the Wandervogel movement, folk music and folk dance would not be incorporated in the interior design until much later, in the 1930s.

Although Attenhuber could still share as an equal and friend in the Duke's love of travel before the First World War, the only role that would remain to him later was being on the receiving end of instructions as the one who had to act on the suggestions the Duke would bring back with him from his extensive travels. 'A beguilingly beautiful castle,' wrote the Duke to Attenhuber on the back of a postcard with a picture of the Château de Gruyères in Switzerland (fig. 124) on it: 'please keep these postcards and return them to me'.

34 Friedrich Attenhuber on his travels, presumably photographed at Schönbrunn in Vienna, c. 1910

As is true of all artists, Attenhuber's origins, status, the conditions under which he lived and his dependent position affected his work. After carefully weighing all aspects of working for the Duke with all the foreseeable consequences, Attenhuber must have viewed it as compromising. Indeed, the compromise turned into constraint; Attenhuber was increasingly dependent on his patron or let himself become so. He worked for the Duke for free board and lodging; his freedom of movement was limited in the extreme. Not until 1921 was an important agreement reached, which entitled Attenhuber to spend up to 15,000 marks that year from the Duke's account. Should the castle be sold, the prospect of being entitled to ten per cent of the sum realised after taxes was dangled before Attenhuber's eyes. However, as the ducal administration informed him in 1944, the offer was not legally binding. As an undated note of his reveals, Attenhuber had always completely relied on it being so: 'Saw in the 10 per cent writing on the sale of the Castle a valuation of my work and, therefore, the prospect of finally also earning something. That was what kept me going.' The 15,000 marks at his disposal disappeared in the galloping inflation; that was a good rea-

41

The relationship between artist and patron

35 Duke Luitpold on an excursion into the mountains, photograph from the 1930s

son for the Duke not to pay Attenhuber in cash, but to let him work for board and lodging. Hence Attenhuber never had the means to leave the Ringberg. How hopeless his situation was is attested by a 'begging letter' he wrote at the age of fifty-one in May 1931 to Duke Ludwig Wilhelm: 'Through the conduct of HRH Duke Luitpold, I have been reduced to begging. Should like to request you humbly to help me out with a few marks. Have received 55 marks in cash from 20 Dec. 1930 to the present.' With reference to his personal income tax declaration under the heading of 'citizens' tax', he wrote to the Munich Municipal Revenue Office in May 1937: 'Cash received from January to November 1936: 50 reich marks; in December 1936: 100 reich marks. Lodging, workroom and provisioning for food (self-prepared) represent the livelihood of the undersigned; for them he must deliver the results of his work. No insurance premiums, no health-care contributions of any kind have been paid for the undersigned. These are the conditions under which an elderly painter subsists.' A list of expenses Attenhuber drew up for the year 1940 comprises 'kitchen receipts, invoices for paints and painting paraphernalia, citizens' tax, medicines' and a cost estimate for free board and heating (300 marks). No cash was left over for him. Thus he was made utterly dependent. There was nothing in the system for him because the paints were intended for the paintings in the castle and 'free' board and lodging left no scope at all for Attenhuber to go anywhere else to live and work. After Attenhuber had lodged endless complaints, an agreement was reached under the terms of which Attenhuber was to receive 100 marks in cash once a month from the ducal administra-

36 Friedrich Attenhuber, after the First World War

The 'court artist' – Friedrich Attenhuber

tion. However, he only benefited from this settlement for the last year and a half of his life.

Without accusation or exaggeration, it is fair to say Friedrich Attenhuber existed in a relationship of subservience to his patron that was not far from indentured servant status. His patron made absolute claims on him: any thought of marriage, for instance, was quashed; Attenhuber was only allowed to receive visitors and models in the kitchen. A lawyer informed him that he was forbidden to accept work of any kind from other patrons. He was also forbidden to show any work of his publicly. The story goes that the Duke justified his refusal to let Attenhuber exhibit his work with the comment: 'For heaven's sake, then he'll become famous.' Attenhuber was isolated, without contacts, without any prospects of making any connections in the art world and the world at large, with which he could only keep up through periodicals. His social situation was probably the main reason why he dragged his feet for long periods and made so little progress with the tasks he was commissioned to perform at the Ringberg.

After the First World War, Ringberg Castle became a prison for Attenhuber and the man who had once been his friend grew into a patron whose demands he could never satisfy. Attenhuber stayed in the castle, a prisoner in the tower in which he had his studio. The artist had let himself be tied to an idiosyncratic project: building a fortified castle in the 20th century. To do that, he had to enter a time zone no longer synchronised with reality, blend historicising elements eclectically with modern ones and abandon his former career. The absurd nature of the castle project may also have turned the tables in the relationship between the artist and his patron. The latter's plans were never completely realised, nor was he happy about this – as if it were symptomatic of his state of mind. The notion of 'building back' at the Ringberg to a bygone Romantic era was just as utopian as the idea of sustained friendship between an impoverished yet talented artist and a highly educated, aristocratic patron.

37 *Friedrich Attenhuber, a late, unfinished self-portrait, mixed media, probably 1946*

38 *Stone commemorating Friedrich Attenhuber (d. 7 December 1947), in the forest on the Ringberg below the Castle walls*

The relationship between artist and patron

The metamorphosis of the villa into a castle

THE 'ANSITZ' ON THE RINGBERG

In 1912, Duke Luitpold, then twenty-one years old, began a project on a plateau on the Ringberg that would keep him occupied for six decades, until he died in 1973. What had started out as a so-called Ansitz, or 'villa with a southern exposure' turned into a castle, over the decades growing into a fortification resembling a stone labyrinth – and this in the 20th century, when castles were at best of interest only to historians of architecture.

Ringberg Castle's building history can be fairly accurately reconstructed from various sources, even though no one involved kept a building log and the records kept by Heilmann & Littmann, the engineering firm that erected the original building, were lost during the Second World War. Important statements relevant to how the construction work progressed and concerning planning, ideas, the giving of commissions and much else are contained in the Duke's correspondence with Friedrich Attenhuber, which is now in private hands, as well as notes the Duke entrusted with the architect Heinz Schilling when the construction work had reached an advanced stage. These records are supplemented by statements made by eyewitnesses, notably the architects Max Berger and Heinz Schilling. Numerous photographs taken during the various construction phases permit conclusions to be drawn about the sequence in which work progressed. The surviving records are those relating to the application of building permission as well as numerous plans, designs, preliminary studies, notional sketches and such a wealth of designs and architectural plans submitted by Friedrich Attenhuber for furnishings and appointments that it is virtually impossible to gain an overview of them or to interrelate them. They are stored at the Max Planck Society.

What led to the idea of building a castle on the Ringberg remains obscure. No remarks on this have come

39 Project for a castle complex on the Ringberg, unrealised, drawing in India ink, c. 1911/12

down from the man who built it, nor has the site on the Ringberg any architectural antecedents. The young Duke discovered the spot while he was out shooting with his cousin Ludwig Wilhelm above the south-western tip of Tegernsee. The Duke was simply enthralled with the breathtaking vista of the Tegernsee valley and on across to the Tegernsee mountains that opened up from the site. What also entered into the picture to influence his decision is the superlative cultural landscape with its historic buildings that had long been in the possession of the Wittelsbachs. Gerd Wolff, a friend of the Duke's from his youth, would later remind him in a letter: '... it was spring 1911 when we became acquainted through sports and studies and you took me to the place on the Ringberg where your house was to stand.' (9 September 1966)

It had to be there, so the Duke acquired a piece of land on the Ringberg from Lorenz and Johanna Bachmair, who ran an inn at Weissach. The contract of sale, dated 14 August 1911, states that the 7.9 hectares (20 acres) of property was bought 'for the purpose of rounding out' property already held. The Duke bought more land, most of it in 1911 and 1912.

The idea rapidly took shape and it was not long before Luitpold was commissioning plans for the building. On 14 February 1912, Friedrich Attenhuber submitted a 'rough cost estimate' for a structure with three towers, a central tract, two side wings, linking tracts and ancillary buildings. The estimate includes a surcharge for transport difficulties and 'lavish furnishings and appointments for the building', for which a 50 per cent surcharge was calculated. Including the cost of building a road but without provision for a water supply and gardens, the overall estimate ran to some 540,000 marks.

From the outset, construction work on the Ringberg was prescribed and accompanied by building regulations. The Duke had considerable problems with obtaining building permission, however. Luitpold's 'personal artist', Friedrich Attenhuber, who constantly had to submit designs for the buildings and their furnishings and appointments, was neither legally entitled to do so nor capable of drawing up concrete building plans that could be worked from. Since Attenhuber was not in a position to be permitted to assume responsibility for any structural or building engineering, the Duke commissioned Heilmann & Littmann, a civil engineering firm, to build the castle. They worked from the commencement of construction and on into the 1920s at the Ringberg and it was their plans that were submitted for building permission.

The first petition for planning permission was submitted by Heilmann & Littmann on 1 October 1912 for the 'construction of a canteen', a rough wooden structure. Not long afterwards, on 15 December 1912, plans were submitted 'for building a castle on the Ringberg, Kreuth village and parish, belonging to His Royal Highness, Luitpold, Duke in Bavaria' to the local authorities for approval. The Duke, however, called the projected building a 'house' and did not use the term 'castle' given in the plans. He failed to say anything at all about the purpose and function of the structure with its four tracts and belvedere.

This exotic-looking plan must have given rise to some bemusement because a letter of appraisal was requested from the Bavarian Association of Vernacular Art and Folklore. Repelled by the style of architecture, the Association was scathingly critical of the plans, to which a letter dated 22 January 1913 attests: 'In appraising the new castle building, it will probably be necessary to ignore the respectable style of architecture usual in the area and it would appear to us advantageous if said building had been modelled

The engineering firm Heilmann & Littmann

Heilmann & Littmann, one of the most reputable south German civil engineering firms, worked in almost all architectural genres. Max Littmann (1862–1931), an architect and partner in the practice owned by his father-in-law, Jakob Heilmann, was the creator of a long list of well-constructed and aesthetically important buildings, some of them outside Bavaria. To name just a few of them: in Munich the Hofbräuhaus, the Orlandohaus, the Oberpollinger Department Store and the Prinzregententheater; in Bad Reichenhall the Spa House; in Weimar the Deutsches Nationaltheater; and in Poznan (present-day Poland) the Stadttheater. A source sums it up: 'In all buildings, there is a large portion of artistic striving and creativity and if a new and individual style has finally managed to be acknowledged in Munich, it is the artists from Heilmann's building company who have contributed not least to that success.' The challenges represented by the castle on the Ringberg were not all that stiff when measured by the standards set by the firm; the Duke probably opted for this particular engineering firm mainly because it was so distinguished.

40 Project for a castle façade on the Ringberg, unrealised, drawing in India ink, 1911/12

Preliminary projects

Sketches for a preliminary project show a castle building facing north, with three wings forming a horseshoe-shaped ground plan. Three-storey round towers at the south-east and south-west corners are integrated in the elevation of the two-storey structure. A high tower forms the end of the east wing on the north side. Crowned by a low pyramidal roof, it recalls a medieval keep. (fig. 39) Its mullioned round-arched windows are meant to look Romanesque. Here, an eclectic blend of Renaissance forms with elements of French classicism emerges. Two subsequent designs show variations pointing to later period styles of architecture, linking Renaissance forms with elements of Art Nouveau and regional Alpine architecture. The towers in particular feature this eclectic style. Decoration is purely ornamental; many of these building elements have no structural function, but are simply applied. (figs. 40, 41) All these plans, however, were more modern in conception than the structure that was actually built.

after good Upper Bavarian examples of castles and Ansitze. … The demands made on aesthetics should … not be regarded as satisfactorily met … [Hence] we should like to warmly advocate a corresponding reworking of the project.' Heilmann & Littmann insisted on keeping the plans as submitted and stated that all designs for the new building stemmed 'from His Royal Highness personally. The royal builder's intention was not 'to build for himself a castle resembling the great Upper Bavarian castles, but rather an Ansitz, modelled after a type of building frequently found in the South Tyrol.' (letter of 30 January 1913) After inspecting a model and following more correspondence, the district authorities finally approved the plans, on 15 March. Indeed, the main tract of Ringberg Castle built before the First World War is in some ways similar to what are known as Ansitze even though the resemblance is more a matter of feeling than substance. No specific building is known which the Duke might have drawn on for inspiration but there are some parallels between alpine tower houses – which are both rustically rural and stately in character – and the Duke's building as first planned.

Just a month after the proposal was approved, construction work began on the Ringberg site, based on the accepted plans. The topping-out ceremony had been held

The metamorphosis of the villa into a castle

41 Project for a castle façade on the Ringberg, unrealised, drawing in coloured ink, 1911/12

by 26 September 1913 and the shell of the building was completed some time the following year.

While Duke Luitpold was serving in the military during the First World War, he never stopped thinking about the castle being built for him. He constantly imparted his notions and ideas to Attenhuber and continually demanded new designs of him. The Duke's preoccupation with his construction site probably also represented a form of self-fulfilment. Luitpold wrote to Attenhuber on 22 January 1915: 'Without me, the house would not even be there … the house is as I want it, has been built for me alone and it would never have been built anywhere in the world in this way had I not lived. … Often I catch myself wondering anxiously whether the building still suits me or whether I am beginning to be indifferent about it. I would rather wish to see it completed, a finished work. After all, I entertained the first thoughts of it coming into being and, with it, I have given an artist the possibility, albeit under my supervision, of creating something extraordinary.'

The building designated as the original structure had been erected by 1914, added to in 1919 and then left much as it was until the Second World War. (figs. 44, 49) The first structure to rise on an outcrop of the Ringberg, in the midst of the Upper Bavarian countryside, was a 'Florentine villa complex'. The Duke, evidently inspired by the rural Ansitze encountered in the Alps, opted for a structure consisting of four tracts surrounding an inner courtyard with a tower abutting diagonally to the south-west and a low connecting structure in front. In the south-east, the building with its four tracts boasts a polygonal corner tower.

The reception rooms are on the ground floor, which is the main floor of the building. A loggia opens out from it on the south side facing the garden.

The four-wing complex was modified in the south-east and south-west. The parts of the building located here were deliberately designed to look different. They were in fact supposed to give the impression that they dated from different and earlier periods.

The main entrance is in the south-west, guarded by a main tower, which is positioned diagonally in front of the four tracts of the building. It in turn is attached to a single-story, U-shaped portico and a steep roof of wooden shingles laterally flanked by turret-like pepperpots with pointed domes. (fig. 46) The massive round-arched portal (fig. 45) of red marble is a commanding feature, standing out sculpturally from the façade with its Tuscan columns

42 The topping-out ceremony at Ringberg Castle, on 26 September 1913. The engineering firm Heilmann & Littmann had commenced construction five months previously.

set on rusticated blocks and surmounted by an aedicule. The entablature above the portal bears the inscription: '19 Ringberg 14'. The aedicule sports the ducal coat of arms. Stylistically, this building is reminiscent of Mannerist and early Baroque architecture. The ends of the rendered portico are emphasised by polychrome sgrafitto in a pattern of quartered lozenges, which recurs on the south façade of the main building. The design of the portico expresses the three functions for which it was intended: first, as a reception space, emphasised by the invitingly curved façade; second, to fulfil the aristocratic owner's need for ostentation: his massive coat of arms is displayed in the elaborately designed portal. Third, the portico clearly demarcates the border between the outer area and the private apartments situated behind it. The functions of the portico are visible and palpably defined by the window grilles, the massive rustication and both heavy entrance doors. The coffered doors are studded with bronze nails and adorned with large door knockers. This is clearly the entrance to a protected retreat to which no one has access without an invitation.

The impression of privacy afforded by the fortifications is heightened by the mighty watchtower rising behind the portico. Guarding the living quarters, the tower is constructed of regular courses of shell-limestone ashlar masonry over a square socle and today has four storeys. Its interior accommodates the main stairwell, which is illuminated by oculi. At the top it is a large room that was once designated as a 'studio'. The north-west wall boasts a large window with a round arch; a balcony supported by three powerful consoles is attached to the south-west wall, the tower's main façade. A blind arch on the wall encloses the round-arched window and the round-arched balcony door. A smaller turret with a stair is connected to the west wing and has a polygonal ground plan. Small windows of varying size punctuate its masonry.

The metamorphosis of the villa into a castle

In its original state, the watchtower was lower and crowned by a colonnade and a low pyramidal roof. In 1922, however, the Duke demanded that the top of the tower be changed ('I can no longer stand the Chinese or Tuscan tower') and had Friedrich Attenhuber draw up suitable designs. The top of the tower, a covered loggia raised above the roof, for which the architectural term is 'altana', was given a more steeply pitched roof in 1923. This corresponded to innumerable examples of towers encountered in medieval Alpine fortresses. In 1957, the tower was given its present appearance by the addition of crenellation, which recalls the towers erected as status symbols by influential patrician families in Italy and elsewhere in Europe during the Middle Ages. The entire south-west corner of the complex appears to encompass earlier structures left over from various building periods. This impression was, it is almost safe to assume, a deliberately calculated effect.

The actual residential quarters behind the entrance hall and the tower look very much more modern and inviting.

Alpine Ansitze

The German term Ansitz (pl. Ansitze) designates a hide for hunters. It also signifies a particular type of castle found in the Alps, which was built by lower-ranking aristocrats or members of the gentry and was something like a tower house and a stately home. Such castles are widespread in South Tyrol, particularly in the wine-growing region around Eppan. Houses of this kind were built in rural settings from the late Middle Ages into the 19th century, a time when medieval fortifications had lost their importance due to the introduction of firearms. Unlike fortresses or tower houses, however, Alpine Ansitze are only slightly fortified. Viewed from the outside, they are closed structures, primarily designed as comfortable, private residences for their aristocratic owners. Ostentation and the formal expression thereof were therefore not eschewed. Architectural elements borrowed from medieval fortified structures, including crenellation, pepperpots, towers and other attributes of feudal architecture, were adapted or taken over wholesale from earlier buildings to demonstrate the owner's high rank.

43 The quarry at Scharling. Most of the stone used to build Ringberg Castle was taken from here. Photograph from the early 1930s

The four-wind complex, built above a socle of natural stone, originally had two-storeys; it was given a further one in 1955. Until then, the horizontal axis of the building had been more strongly emphasised.

The south façade, the sunny side of the building, is asymmetrical in design, which makes it look picturesque, lively and indeed rather Mediterranean in character. (fig. 47) Loggias articulate the ground and first floors. The lower loggia opens on to the garden terrace with four high round arches. The upper loggia is designed as a broad, shallow opening in the wall with three simple round pillars. The lean-to roof above it joins it to the façade. The south-east corner, built on a polygonal base and finished off with a helm roof, looks like a squat tower – yet another feature intended to be taken for a relic of an earlier building.

The main building was originally rendered in dark reddish brown. (figs. 44, 49) The window soffits, cornices and arcades were picked out in white. However, it was not long

44 Ringberg Castle. The original building, seen from the south-east, before 1923

In the 1920s a terrace was laid out along the north façade, stretching in an arc between the two towers. From here the view across Tegernsee and the arrestingly beautiful valley is breathtaking. (fig. 51)

The east and west façades are simple and clearly articulated. The northern section of both façades, each of which have five axes, projects from the main block like an avant-corps. On the east façade there is a red marble arched portal in the fourth axis. A stair that turns at right angles leads up to it. (fig. 53) On the west façade, there is another portal, placed directly next to the stair tower.

The main building encloses an almost square inner courtyard, which is entered from the castle's ground-floor corridors. (fig. 52) Above a high socle of natural stone, blind arcades, visually emphasised by dark framing, articulate the ground-floor walls. The windows along the façades are embellished with finely worked red marble heads. At the centre of the south tract is a door that opens on to the courtyard. Across from this, in the north tract, three steps lead from the courtyard to an open arcade with slender Tuscan columns and round arches. Doors leading to the corridors are located at both ends of this arcade. The rear wall boasts a plaque at the centre inscribed with the motto: 'Tempora mutantur, nos et mutamur in illis [The times change us and we change with them]. 1960'; an ornate 'L' stands for 'Luitpold'.

before the building was rendered in light yellow and decorated with coloured elements such as a pattern of quartered lozenges and coloured reserves as well as lozenge quartering on the pillar shafts and other elements, which gives the whole structure a cheerful look. The garden and the terrace, which was laid out much later, as well as the Summer House erected in the 1930s, which will be discussed later, contribute to enhancing this mood.

Unlike the south façade, the symmetrically designed north wing is austere and of classical astringency. Articulated in five axes, the ground floor of this façade was soon embellished with an open, triple-arched arcade linked to the wall by a lean-to roof. The central entrance arch is flanked by two further arches, which are closed by parapets in the lower zones. An open stair leads to the north terrace, which was flanked by two unrendered, originally freestanding pavilion-like round structures with pagoda roofs. The first version of the clearly articulated north façade was relatively low and fitted into the landscape without standing out from it. (fig. 48) After the building was raised, the height of the entire building was far more apparent.

45 Ringberg Castle. The red marble portal of the main building is adorned with the armorial bearings of the Palatinate Wittelsbachs, which Duke Luitpold used.

The metamorphosis of the villa into a castle

This courtyard recalls Mediterranean architecture, a patio transplanted from Spain or the inner courtyard of an Italian Renaissance palazzo. Moreover, on the Mediterranean model, a fountain spouts here, at the centre of the courtyard. It was designed by Friedrich Attenhuber. The basin of the fountain, from which a flower calyx with a stylised inflorescence to hold a nozzle stands on a base in a round depression, is surrounded by a railing. The courtyard paving consists of brick moulded into special shapes to form a regular pattern. In the corners, mosaics of black and white river pebbles with inscribed circles form a contrast to the rest of the paving. The courtyard floor corresponds to the façade in colour and form.

Numerous impressions the Duke gleaned on his travels, particularly some of those journeys to Mediterranean countries on which he was accompanied by Friedrich Attenhuber, have clearly left their mark on the architecture. Luitpold evidently wanted his house to unite a variety of southern features with a structurally solid style appropriate to the Alpine landscape. (figs. 49, 50) This architectural concept is primarily evocative of built history, probably with the goal of alluding to the building tradition of the Wittelsbachs. From the outset, the intention was to create the impression of a structure that had grown over centuries, a house with a past, which in its way was also supposed to illustrate a family tradition of its own. The two-storey structure with its four tracts and the ground floor as the main floor would seem particularly indebted to the Renaissance. This is especially emphasised by the loggia facing the garden on the south side and the Tuscan inner courtyard. By contrast, the polygonal, tower-like south-east corner and especially the obliquely adjoining

46 Ringberg Castle. A curvilinear portico forms the entrance, behind which rises the watchtower.
pp. 52/53: 47 Ringberg Castle. A parterre extending along the south façade. Building on the Summer House (right) began in 1936.

The 'Ansitz' on the Ringberg

48 Ringberg Castle. 1919 drawing of the north façade of the original building. Pagoda-like towers that were not linked to the building originally flanked the façade.

pp. 56/57: 51 Ringberg Castle. View across the north terrace to Tegernsee

medieval-looking tower are evidently intended to suggest even earlier architectural periods. The concave portico with its Mannerist-early Baroque door, by contrast, is meant to simulate a later period style.

But Luitpold was tortured by doubts about his choice of style. In a letter written to Friedrich Attenhuber in 1918, the last year of the Great War, he admitted:

'Naturally it would also have appealed strongly to me to make a new building with you, something more liveable, even more comfortable, much less Renaissance and less Italy without, however, eschewing all caprices blown in by a south wind. For that, the impression I received in earlier years from the charms of Spain, Italy and the Tyrol is too strong. Enough of that can still be made up for in the interior design. And this house is to be finished; too many hopes, memories and too much of the best of what we two had to give are in it to have it pass still unfinished into other hands. If you were twenty and I ten years younger … but as it is: to start over again, with all the bother with firms and businesses – it's even getting too late now to do some painting and lead a quiet and independent life of one's own. And after the war years, one will be even happier to have a quiet place that is rather remote and is already finished in essentials. 'Not long afterwards, Luitpold confirmed, now in a far more contented vein: 'In its way, this house and everything connected with it is, after

49 Ringberg Castle, seen from the south, photograph, before 1923

54 The metamorphosis of the villa into a castle

all, a finished work, even though there would have been many other ways of accomplishing the task. We should definitely try to bring this thing to an end.'

After the Great War, Luitpold insisted that the house be finished; after all, he was now firmly resolved to take up residence there.

FROM 'ANSITZ' TO 'FORTRESS'

Ringberg Castle was originally set in open countryside and was not surrounded by walls. All that demarcated the grounds was a terrace parapet on the south side. However, all plans drawn up after the First World War were tailored to converting the complex into a 'fortress', 'without … eschewing all caprices blown in by a south wind', as its owner put it. The structures erected from then on document the progress towards fulfilling that aim, still unachieved by the time the Duke died, and were to be even further developed as the plans reveal. Duke Luitpold stubbornly persisted in building with the ideal of a fortress in mind, with extensive 'fortifications' encircling and incorporating the main complex. The 'Mediterranean' air of the early period was thus almost entirely lost.

Luitpold was working towards a private 'retreat' of his own on the Ringberg, a refuge in which he might lead the life he envisaged, where he could withdraw from a world that had radically changed. There he would be fleeing an era marred by profound existential changes and uncertainties, a world in which the political importance of the nobility had vanished with the end of the monarchy. Luitpold lived only temporarily on the Ringberg. Taking up residence within the fortified walls of his castle, where he would be served by a feudal retinue of servants and might entertain a host of distinguished guests, remained his favourite intellectual pastime. He invested a great deal in every respect in that dream.

Typical of Luitpold's building operations after the First World War and even more so after the Second is that the structures were left as incomplete shells. 'Architecture is the mother, the trunk round which all the other visual arts are entwined! It is more important than anything else,'

50 *Villa Medicea della Petraia near Florence. An old postcard picked up as a souvenir by Duke Luitpold on his travels. Buildings like this influenced the architecture of Ringberg Castle.*

52 *Ringberg Castle. The four wings of the main building enclose a rectangular inner courtyard with a fountain designed by Friedrich Attenhuber.*

The metamorphosis of the villa into a castle

he wrote in 1922 to Attenhuber, his 'personal artist', thus clearly indicating where his priorities lay. Stylistically he had opted for the 'High Middle Ages'. The first structures erected after the Great War were dotted about like models in the context of a fortress: a high, free-standing keep, the Gatehouse Tower and a hermitage. (fig. 62) Friedrich Attenhuber executed the designs for these buildings; the plans to be submitted for approval were drawn in 1924 by the engineering firm of Heilmann & Littmann. In the latter half of the 1920s, construction work came to a halt, presumably because of the uncertain economic situation. During that time, Luitpold had Attenhuber design ambitious fortress projects. The artist came up with numerous proposals. Some of them were drawn on picture postcards of Ringberg Castle, which he retouched to add more towers, raising and enlarging some, as well as walls and terraces to create something that looked like a fortress. It was supposed to have the appearance of a monumental complex with simple cubic forms and rustic ashlar masonry and, by being raised, to stand out from the landscape. (figs. 54–57)

In the early 1920s, what was called the Guest Tower was built in the south-east corner of the complex. It is also known as the 'Studio Tower' or the 'Keep'. This tower marks a break in the building operations on the Ringberg because once it and all structures that followed stood, what had been termed a 'castle' was now re-interpreted as a 'fortress'. The free-standing tower looks like a late medieval keep or French donjon, to be used as living quarters or space for storing provisions. Initially the high, slender tower must have looked odder in the complex as a whole because the main building, then only two-storeys high, was considerably lower than it is today. Nor was its belvedere tower as high as it appeared once it had been remodelled. The Guest Tower is built of hewn ashlar masonry and boasts a steeply pitched saddleback roof. On its west side, off-centre, stands a nearly round tower with a stair inside and a conical roof. Next to it is the entrance portal, with the date 1922 engraved in the keystone at the crown of the arch. Most of the windows let into the walls of the tower are small. However, on the north side, large windows with round arches on the first floor indicate that the rooms behind them were to be used as a studio. The south side, which faces outwards, was particularly impressive in design. The massive substructure of the tower is visible on the outer slope and it looks very high from there. The effect of great height is visually enhanced by a buttress that tapers towards the top. Above this buttress is a shallow oriel window with a shingle lean-to roof. Behind it, a solitary room might be imagined. Above it a polychrome coat of arms adorns the façade. (fig. 59) These are the Wittelsbach armorial bearings, quartered into two fields with lions and two with white-and-blue lozenges in a diagonal arrangement.

All that the Duke paid much attention to was building the outside of the tower. Friedrich Attenhuber had set up a temporary workroom on the first floor in the unfinished structure and lived there under wretched conditions. (fig. 25) Not until much later, after Ringberg Castle had been acquired by the Max Planck Society, was the inside

53 *Ringberg Castle. The east façade*

54 Ringberg Castle. The single-storey original building, seen from the south-east. A more steeply pitched roof has been sketched in pencil on the tower in the photograph than was actually built in 1923, as have wall decorations, which are used as structuring elements.

55 Design for a tower on the Ringberg, north-west of the main building, unrealised project, drawing, 1925, Heilmann & Littmann

The metamorphosis of the villa into a castle

56 View of an idealised castle on the Ringberg, pencil drawing, c. 1925

57 Ringberg Castle. Old postcard with drawing on it. In the 1920s Attenhuber sketched on numerous picture postcards variations on his visions for remodelling Ringberg Castle.

From 'Ansitz' to 'Fortress'

58 *Ringberg Castle. The so-called Guest Tower at the south-east corner of the complex, built in the early 1920s*

The metamorphosis of the villa into a castle

59 Ringberg Castle. The south side of the so-called Tower is adorned with the Palatine Wittelsbach armorial bearings.

of the tower finished and accommodation for guests provided there so that it finally lives up to the name 'Guest Tower'. The walls are now overgrown with vines, which make them less look less forbidding.

The Gatehouse Tower was built in 1924. (fig. 60) It forms a barrier to the road running from the valley and represents the main entrance to the castle complex. On the entrance side, the edges of the wall are designed as barbicans. A small door called a 'postern' is cut into the large plank door, which leads into the gatehouse, where a caretaker's flat was supposed to be built on the first floor. Before the Second World War, in 1937, the Gatehouse Tower was remodelled. In this connection, Friedrich Attenhuber made his first appearance as the author of plans to be submitted for building permission. The structure was raised and designed to accommodate a massive gabled roof that jutted far forwards in a singular manner. It was supposed to reflect Alpine architectural tradition. Behind the Gatehouse Tower, a short drive lined with chestnut trees leads to the portico of the main building.

Abutting the Gatehouse Tower on the west slope is an kitchen tract, designated a 'hermitage', which boasts an asymmetrical gable with masonry shoulders and is buttressed on the valley side. Stairs lead from the drive to this building.

The idea of erecting a chapel on the Ringberg fired Luitpold's imagination to wild flights of fancy: 'Since it would be the proper thing to do to build a little church in this wilderness and a consecrated place for meditation would be entirely welcome to the local residents, who are growing more pious with age, and for whom it might not always be easy to go to church, we propose to build an inviting little chapel, particularly since almost no ancient castle complexes are without one.' Thus Luitpold to Attenhuber on 19 February 1922. Luitpold planned to build his 'little church' as a separate structure, situated at some distance from the main building on the western slope '… so as not [to be] too close to places intended for the celebration of boisterous festivities' and it was to be '… not all that small so that there will be room for all domestics at the castle and it looks impressive from a distance …' Modelled after early Bavarian chapels from the 17th century, the chapel was to represent a local style of vernacular architecture and Luitpold shared his fantasies with Attenhuber: 'I can already see the little church standing, with a shingle roof and a bell for ringing, half rustic, half ducal … .' Luit-

60 Ringberg Castle. View from the south of the Gatehouse Tower and the chapel

pold had concrete ideas, some of them very detailed, on how it was to be designed and appointed. He actually visualised his chapel '… inside [with] frescoes, carved altars, stained-glass paintings, a woven or embroidered antependium, etc.' Today the chapel is hard to find in the labyrinth of walls later erected in the area above the Gatehouse Tower. The impression intended to be created by it from a distance was lost because buildings went up around it. The chapel is a small stuccoed hall church with a 4/10 chancel in the north-east and a small tower with an onion dome on the entrance side in the south-west. The building stands on a rocky elevation; it may have been the terrain that did not allow for the usual ecclesiastical east-west alignment. On the south-east side, which abuts a steep slope, considerable buttressing was needed. This is where the sacristy rises up and is covered by a skillion roof. There is an annexe on the north-west wall, with a stone bridge leading to its upper floor. This structure accommodates a sort of gallery, with an arch opening from it to the interior of the church. A west gallery was planned for the interior as well as a massive altar wall that would have been flanked by side passages. Friedrich Attenhuber executed designs and made cartoons for the wall frescoes; this building, however, was not completed during the Duke's lifetime. The present-day chapel, of simpler, more austere design, was built in 1982 by the Max Planck Society.

Ringberg Castle remained a construction site as long as Luitpold lived. At his behest, new building projects were always being started before others could be finished. This dreary state of affairs and financial straits made the Duke at times lose his enthusiasm for the project. In the mid-1920s he even thought of selling the whole complex. But by 1928 Luitpold was already again busy with plans for enlarging the gatehouse and the keep and was even thinking about remodelling the main building.

Apart from the south wing, the 1930s saw the building of the Summer House (also designated the 'Gazebo' or 'Teahouse'), which was, however, left unfinished in 1936 and not completed until the late 1960s. The main floor of the stuccoed Summer House, which is reached by an outside stair on the north side, sits on a substructure of ashlar masonry. The corner pilasters and window frames are dec-

orated with the typical coloured quartered lozenge pattern, similar to that found on the lower loggia of the south wing. The room on the upper floor of the Summer House is decorated in bas relief, for which Friedrich Attenhuber had made cartoons as early as the 1920s. The stuccowork was executed by Ferdinand Hauk, but not until the 1960s. The large relief panels take up almost the whole width of the walls. Mythological and pastoral scenes such as Europa with the bull, shepherds, sheep and a grapevine as well as a carpe-diem motif are depicted; the vaulted ceiling is decorated with medallions in which tritons, Cupid, Prometheus and a pastoral scene appear. When the stuccowork had been painted, the Duke's comment on it was: 'To be honest, it's actually too cloying'.

A chemin-de-ronde, erected in 1936, adjoins the Summer House stairs. Built of wood and roofed, this structure leads to the outer east wall, where it ends in a roofed watchtower. A plaque bears the inscription '1936 FA', above which compasses are discernible, presumably to indicate that Friedrich Attenhuber was the architect.

Between the Summer House and the south-west corner of the main building runs a curving wall. In the curve is a bench made of specially moulded bricks. At the centre stands a roughly life-size bronze Cupid, which is fully in the round, above a shallow fountain basin of red marble. Cupid is the companion piece to a bronze figure of Psyche

61 Ringberg Castle. The chapel seen from the south. Behind the wall, a stair leads to the roofed-over alcove with the urn containing the Duke's ashes.

62 Ringberg Castle. Old postcard of the entire complex, seen from the south, aerial photograph, c. 1925. The main building is enclosed in a ward with a reinforced wall to the south, the Guest Tower (right), the chapel and the Gatehouse Tower to the left.

63 Ringberg Castle. The chemin-de-ronde in the garden, seen from the north

pp. 68/69:
66 Ringberg Castle. The cheerfully Mediterranean-looking gardens with the pool are set against an imposing mountain backdrop. A stele with a Janus head by Hans Vogl (right) stands in the Rose Garden.

64 Ringberg Castle. Friedrich Attenhuber's mark and the dating '1936' on the chemin-de-ronde of the east wall

in an alcove on the west side of the south-wing loggia. Friedrich Attenhuber designed both statues, but they were not cast in bronze until the 1960s, when the sculptor Ferdinand Hauk had them made. The link between the two figures was, however, broken when a pergola, a pavilion-like structure open on three sides with a steeply pitched saddleback roof, was erected in front of the west alcove. The pergola has a handsome wooden ceiling with geometric decoration bearing the date '1940/41'. Since that date, the statue of Psyche has been concealed by this building. Very close to the bronzes of Psyche and Cupid in the antique manner on the south façade respectively the so-called Sun Wall, there is a mural by Friedrich Attenhuber on the narrow east side of the loggia depicting a peasant lad jumping over a cow in a burst of high spirits. This rather odd-looking mural gives a preview of the style of painting Attenhuber had developed since the 1920s: reality is heightened to sickly sweetness that is cliché-ridden. However, more on this elsewhere.

The design of the southern part of the property basically goes back to Friedrich Attenhuber. Here, his ability to design an architectural complex as a total work of art and to inform it with a painterly mood comes into its own. Several media and genres converge here. Architecture, sculpture, painting and nature itself today lend the south side an atmosphere that is both cheerful and elegant even though the overall effect as originally intended has been modified by later buildings. One might, of course, be rather surprised at the boldly eclectic blend of period styles that evolved over the years. Attenhuber did not live to see the complex finished. Not until 1956, nearly ten years after his death, was the porch he designed added to the south wall of the Summer House. Its upper storey is a loggia. Below it an alcove opens out behind a round arch, with another round-arched alcove let into the back wall. Below the entrance arch stands a bronze statue of Flora, the work of the sculptor Bernhard Bleeker (1881–1968) and dating from 1961. Flora closely resembles another figure made by Bleeker, for the Crown Prince Rupprecht Fountain on Marstallplatz in Munich.

The metamorphosis of the villa into a castle

65 Friedrich Attenhuber, *Peasant Lad Leaping over a Cow*, mural on the narrow east wall of the loggia on the south façade, 1943

From 'Ansitz' to 'Fortress'

67 Ferdinand Hauk (after designs by Friedrich Attenhuber), bronze statue of Cupid in front of the so-called Sun Wall on the south terrace, 1960s

68 Bernhard Bleeker, bronze statue of Flora in an alcove on the south side of the Summer House, 1961

From the mid-1940s to about 1960, Max Berger (1899–1991), who had run a building firm in Tegernsee since 1932, was employed as chief builder at the Ringberg. After Attenhuber's death in 1947, Duke Luitpold put Max Berger in charge of supervising ongoing work on the construction site. Berger's job was limited mainly to outdoors building operations. Even in the period after the Second World War, Luitpold attached the most importance to the outside work. He left the responsibility for furnishing and decorating the interior of the new buildings to posterity. All he cared about by then was the external appearance of the buildings. So he had stage-set architecture with walls, towers, oriel windows and crenellation as the attributes of a fortified complex intended to look impressive in the surrounding countryside. How the castle may have looked as viewed from the valleys during the decades while it was under construction can only be roughly reconstructed from old photographs because they were composed with the close-up rather than the long-shot view in mind. The high forest around the castle had to be thinned continually to keep sight lines open. It was obviously the intention to present a showy side to Tegernsee, which explains why the north façade was changed and raised more than once. Viewed from the Kreuth valley, the complex is impressive for its powerful, horizontally articulated longitudinal tract stretching between massive tower blocks and delimited to the south by crenellated walls. The sight lines to the east, on the other hand, were probably intended to keep the view open to the Wallberg.

In 1955, Max Berger carried out the major remodelling of the main building, a project that had been in the planning stage for too long. The wings were raised by a storey, which was intended to include staff accommodation and guest rooms.

The Duke insisted: 'North tract must be redesigned into a fortress.' As a result, the round, originally free-standing, pavilions were converted into high towers with four storeys and tied into the north façade by means of walls.

The metamorphosis of the villa into a castle

A round-arched entrance and a stair with two flights lead into the east tower. The west tower has been converted into a modern lecture hall. The north towers look like massive defensive towers and their conical roofs are visible from afar. The north wing itself was, like the other tracts, raised by a storey and a two-storey loggia was built on to the façade. In the lower loggia, the central entrance arch is higher than the arches flanking it, which rest on square supports. The upper loggia, with segmental arch openings resting on red marble supports, boasts a slightly protruding central balcony with a grille.

The watchtower at the south-west corner of the main building was topped with crenellation rather than an altana. Remodelling made the main building look even more forbiddingly monumental. Hence it fitted into the overall 'fortress' look established by the addition of the Guest Tower, the chapel and the Gatehouse Tower.

In the late 1950s, the sloping ground west of the main building was converted into an 'inner bailey' or ward. At its centre is the so-called Terrace of Destiny. The terrace is roughly trapezoidal in shape and is level with the roof of the main building. At the centre of the inner ward is a red marble fountain, known as the Norns' Fountain. Three female figures fully in the round and wearing long robes stand around a column surmounted by a 'fir apple' (archaic term for the emblematic 'pine cone') rising from a basin cut from a single block of stone. One of the figures holds a distaff, with threads running from it through the hands of all three figures. This identifies them as the Norns, who in Teutonic mythology spin the threads of fate and thus determine the destinies of mortals and immortals. Hence the name Terrace of Destiny for the inner ward. Around the base of the fountain, a frieze composed of different-

pp. 72/73: 70 Ringberg Castle. View of the Terrace of Destiny with the Norns' Fountain and the Tegernsee valley in the distance

69 Ringberg Castle. View of the north terrace with the north façade

coloured granite stones is divided into twelve fields, each containing a sign of the zodiac. The fountain is the work of the sculptor Hans Vogl (1898–1988). From here a view opens out over the massive towers of the main building and across the countryside to the Wallberg.

In the opposite direction, on the side facing the slope, the Garden Hall, or the 'Tower marking the end of the garden', as it is called in the building records, forms an imposing backdrop for the Norns' Fountain. And that was probably the sole reason for, indeed purpose of this structure, which was built between May 1958 and October 1959. It is simply articulated: a two-storey loggia is set between two massive squat round towers. The lower floor boasts three round arches; the floor above is designed with a flattened segmental arch. The lower floor, which is called the Garden Hall, is paved with Solhofen limestone flags. A red marble fountain surmounted by a relief of a stag's head resembling a capital is worked into the rear wall. The entrances to the lower floors of the round towers are at both ends of the hall. From each, a stair leads up to the upper floor of the Hall.

The Terrace of Destiny is supported by a massive retaining wall, with an open arcade consisting of five arches resting on squat columns. The central arch opens onto a terrace in front. This structure, which rounds off the overall appearance of the complex, was not the work of Max Berger but rather of his successor, the architect Heinz Schilling, of whom more later. A round-arched alcove clad with a mosaic depicting stylised iris and a sun is let into the rear wall of the arcade above a fountain basin carved from a single block of fossiliferous limestone. A bronze doe's head by Ferdinand Hauk emerges from the

71 *Ringberg Castle. An inner ward of sorts was constructed to the west of the main building, surmounted by the Garden Hall, which is flanked by towers. Bottom left: the Birthday Tower, built in 1960*

The metamorphosis of the villa into a castle

72 *Ringberg Castle. A view of the 'inner ward' arcades below the Terrace of Destiny*

alcove wall, its mouth forming the waterspout – a functional touch. At the end of the arcade, stairs lead off to the right and left to the Terrace of Destiny. The arcade is flanked by corner turrets with pyramidal roofs. From these turrets, roofed-over gangways lead like tunnels to the upper round turrets of the Garden Hall. Apart from the gangways, stairs lead to the Terrace of Destiny.

Max Berger's last commission on the Ringberg was to build the north outer wall in 1958. It rises in three stepped sections and is designed to accommodate a small watchtower with a pyramidal roof. Synchronously with the construction of the wall, work began on several ancillary buildings on the north side, intended to house living quarters and reception rooms, a larder and pantry space, a film theatre and a bowling alley. Left unfinished, several of

73 *Ferdinand Hauk, fountain decorated with a mosaic and sporting a bronze doe's head in the 'inner ward' arcades, 1960s*

From 'Ansitz' to 'Fortress'

> ### Hohenwerfen Fortress
>
> Hohenwerfen, a mountain fortress south of Salzburg, was pivotal to Duke Luitpold's 1950s building plans. A prime example of 13th-century Alpine defensive architecture, it so impressed him that he borrowed various building elements and architectural motifs from it for the Ringberg. The features modelled on Hohenwerfen the Duke had incorporated in the Ringberg were the Garden Hall arcades, the gangways following the slope in descending levels and ways in which some walls were structured with recessed towers or round towers topped with conical roofs. In 1938, Hohenwerfen, which had burnt down in 1931 and afterwards had been only partly rebuilt, was sold by government decree to the National Socialist District Council. During that period, the complex was enlarged on stringently austere lines. During the Second World War, Hohenwerfen was used by the NSDAP as a training centre.

them were demolished in 1983 to make room for the new Max Planck Society seminar building.

The Duke hired the Munich architect Max Schilling to succeed Max Berger for the remaining building projects. Heinz Schilling worked at the Ringberg from 1958 until Duke Luitpold died, in 1973.

By the time Schilling started work there, some buildings had been remodelled and new ones erected in line with the fortress concept. He was responsible for ensuring that measures were adopted to drive forward the remodelling operations as prescribed. An experienced architect, Schilling was left with hardly any scope for finding creative solutions of his own. His task consisted in consolidating his patron's ideas and adding some personal touches to the existing eclectic conglomeration of styles. Schilling's skill as a designer is apparent wherever he was able to incorporate his ideas into a project. He succeeded in tying some individual buildings into a uniform, overarching plan and in arranging the architectural structures. He left unchanged the core of the complex, the main building erected after Friedrich Attenhuber's designs.

74 *Hohenwerfen Fortress near Salzburg. This complex exerted a formative influence on the design of the Ringberg Castle 'inner ward'.*

The metamorphosis of the villa into a castle

75 Hohenwerfen Fortress near Salzburg. Duke Luitpold was very taken with this structure's massive walls and chemins-de-ronde.

Heinz Schilling saw to it that Ringberg Castle was encircled by walls and towers and that the extant walls were extended. The walls differ considerably from section to section and vary greatly in design. They are built with crenellation and corner turrets, interrupted by watchtowers and bartizans, laid out with chemins-de-ronde or interestingly linked to other buildings. They provide continually changing views; historical models are frequently quoted or evoked. Consequently, the walls round Ringberg Castle represent far more than pragmatic measures for securing and enclosing the grounds. (As it turned out, the security aspect came to be greatly appreciated during the Second World War, when Munich's Stadtmuseum stored artworks from its holdings at Ringberg Castle for safekeeping.) The walls have become a sort of adventure walkway leading through a model medieval fortress complex. A walk round the parapets turns out to be an excitingly varied discovery tour, complete with viewpoints and places to linger and savour the prospects. Spectacular views of the surrounding countryside have been calculated to maximum effect in the 'entertainment programme'.

The area of the 'inner bailey' in the west looks like a stone labyrinth consisting in a complex system of stairs and walls. In the west rises a lofty, mantelet-like structure. The top of the wall, which has two shells, is formed into a sort of chemin-de-ronde. At its northern end, at an angle to the passage leading to the Terrace of Destiny, in 1917 Duke Luitpold had a place for an urn made, where he intended his mortal remains to be kept. This area is roofed over with a shingle lean-to roof. A plaque bearing the simple inscrip-

Heinz Schilling

Schilling studied architecture at Munich Technical University (then Polytechnic) under Professor German Bestelmeyer from 1933 to 1937. In 1939, Schilling was hired to work in Hermann Giesler's private practice. Giesler had been appointed 'General Architectural Councillor for the Capital of the Movement' (i.e. Munich) by Adolf Hitler in 1938. Between 1940 and 1944, Schilling was comandeered for wartime building projects, such as planning housing for Hitler's bodyguards at the 'Buchenhöhe' settlement on the Obersalzberg. After the Second World War, Schilling worked as a reconstruction consultant and designed important public and private buildings in Munich. His style is a blended the 'classical Italian palazzo formal canon' with the characteristic stylistic devices employed during the conservative 1930s and 1940s.

From 'Ansitz' to 'Fortress'

tion 'L-HIB-1890-1973' (Luitpold-Duke in Bavaria) is visible on a piece of masonry standing out from the wall; beneath it, crossed blossoms are depicted. The urn containing the Duke's ashes was placed in the alcove behind it. (fig. 12) A covered stair leads from the place where the urn stands to the arcade. In the south-west, the west wall ends at a high portal structure with a round arch. It is designed like a fortress gate with a corner bartizan and a slender round tower. On the west wall, a stair leads to a storey built above the portal to link the tower and the bartizan. From here the long chemin-de-ronde above the west wall can be explored. In the outer ward, a short drive leads to the south-west portal. Here, there is a red marble Bavarian coat of arms bearing the date '1960' above the portal arch.

The walls enclose a space in front of the chapel and the kitchen tract; here it is again fitted out with a corner turret. The south tower is incorporated into the outer wall to the east of the Gatehouse Tower. A modest, cubic structure erected in 1961, it is flat on top. A rectangular bartizan

76 *Ringberg Castle. Near the chapel in the angle between the west wall and the arcade, Duke Luitpold had a place laid out where he wanted the urn containing his ashes to stand.*

77 *Ringberg Castle. The portal in the south-west and the west wall with a chemin-de-ronde of sorts*

The metamorphosis of the villa into a castle

78 Ringberg Castle. View of the south wall reinforced with swallow-tail crenellation as tall as a person. On the left the Summer House and the so-called Guest Tower

juts out from the south side. A broad, round-arched entrance on the court side leads into the tower, which was designed by Friedrich Attenhuber.

The south wall, constructed of ashlar masonry, is impressively topped with swallow-tailed Ghibelline merlons almost as tall as a person. Models for walls of this type are encountered in northern Italian or South Tyrolean defensive architecture. In the east, the wall ends at an observation platform that looks like a round bastion. The Château de Gruyères, (figs. 81, 124) which Duke Luitpold so greatly admired, may have been the model for this architectural feature.

Adjoining the Guest Tower to the north is a high section of wall that also encloses the small garden to the east. A round-arched opening in the wall leads to a small observatory oriel window. Behind the little garden, the east wall, which was remodelled by Heinz Schilling in 1968/69, runs north. Part of this wall can be walked along and earlier sections of the wall have been incorporated in it. An indication of this is a small gate in the north section, above which the date '1924' is discernible. About half way along the wall is a roofed-over observation tower with a stair leading up to it. Here the vista opens out to the Wallberg. A covered gangway along the wall coping leads to another observation tower at the north-east corner.

In the early 1960s, Heinz Schilling redesigned the layout of the outer ward of the Ringberg. The first thing he

pp. 80/81: 79 Ringberg Castle. View of the Summer House (left) with bronze statuary and the garden (right)

From 'Ansitz' to 'Fortress'

80 Ferdinand Hauk, bronze bull's head on the north wall of the garden, 1960s

did was to design the western slope of the 'inner ward'. This was done by supporting the lower part of the area with a high retaining wall and laying out the slope in several terraces. A small, two-storey tower with a mansard roof, known as the Birthday Tower, was built on the lower slope. The ground floor of this structure opens on three sides with round arches. Inside, it boasts a groin-vaulted ceiling; its boss bears the date '1960' – the year the tower was built, on the occasion of Duke Luitpold's seventieth birthday. The consoles of the vault are decorated with reliefs, each consisting in two lions and two lozenge fields. Above the Birthday Tower stands a small structure resembling a wayside shrine.

After the 'inner ward' area was designed, the above-mentioned little garden was laid out with choice planting on a protected surface area surrounded by high walls between the main building and the Guest Tower. (fig. 79) On the north wall of this garden is the Bull Fountain by Ferdinand Hauk. A bronze bull's head, worked fully in the round, with gilded horns and eyes decorates the wall above a rectangular basin and a waterspout. Another work of Hauk's, a statue of Pan, is closer to the Guest Tower. Partly concealed by bushes, Pan looks towards a statue of Flora in front of the Summer House.

Heinz Schilling laid out a spacious terrace on three levels in front of the south wing of the main building. The upper terrace extends from the pergola in the west to the Sun Wall and Summer House in the east. A swimming pool is set into the central terrace, with a rose garden and a goldfish pond in front of it. The focal point of the rose garden is a shell-limestone statue of Janus by Hans Vogl. The bearded faces look north to the main building and south to the wall. The lower terrace is bounded by the crenellated wall. Terraces were also laid out in front of the chapel and the kitchen tract. In front of the chapel, the terrace sports an open arcade. Finally, in 1969/70, the terrace fronting the north tract of the main building was considerably widened on the side towards the lake, an operation that necessitated massive retaining structures on the slope. The outer corners of the terrace are delimited by two bastions to underscore the fortress effect created by the massive round towers on the north façade.

The last architectural project initiated by Duke Luitpold, albeit not completed until after his death, was the cistern tower behind the 'inner ward'. This structure is entered from the rear wall of the upper storey of the Garden Hall. The cistern proper is a simple, functional structure made of concrete. It was clad with fossiliferous limestone ashlar masonry and a pyramidal shingle roof to 'disguise' it as a defensive tower.

When Duke Luitpold died in 1973, he left Ringberg Castle a skeleton. At that point, most buildings were still unfinished. Further projects put forth by the architect Heinz Schilling since the early 1960s and officially approved lay in a drawer.

The intention had been to erect a keep 30 metres (98 ft) high to the west of the Garden Hall. An octagon is superimposed on the plan of this seven-storey (!) pentagonal tower with an octagonal inset, supposedly modelled on Castel del Monte, built by the Holy Roman Emperor Frederick II. Heinz Schilling was sent by the Duke to Apulia to study that imposing structure. It is difficult to see from the plan in what way Castel del Monte could have functioned as the model for the external appearance of the keep but the Duke was in any case extremely impressed with the building that remains as a monument to Frederick II.

According to the plan, the keep on the Ringberg would have united the functions of a water tower and living quarters. The cistern was to be housed on three storeys above the ground floor, which was to be reserved for technical facilities. The two floors above the cistern were

81 Château de Gruyères (Switzerland). This fortified castle with its enceinte and round bastion exerted a strong pull on Duke Luitpold.

intended to house the Duke's private apartments, featuring a groin-vaulted main room with a large window and a balcony facing east. The structure would have been surmounted by an altana. On the plans, the structure looks massive and forbidding and its wall surfaces for the most part unfenestrated.

Another extensive new project that was in the planning stage by 1962 was a barbican, in which the gatehouse entrance was to be redesigned. Here, too, elements of the structure were borrowed from medieval defensive architecture or developed from it. On the plan, a new gatehouse connected to the north at the chapel by an earlier section of wall boasting an inner covered gangway bars the entrance road. The Duke was very much concerned with 'keeping dry' by remaining under roofs while walking along all sections of the wall.

Inside what is now the car park in front of the south wall, a two-storey tract on a lower level was supposed to rise above a high-ceilinged basement. A half-round tower, deviating slightly from the overall alignment, was designed for the south-east side, a direct borrowing from Hohenwerfen Castle. The basement and ground floor were to provide parking spaces for thirty-one vehicles. Cars were to be moved into the car park by means of a conveyor-belt system. The idea was to graft an ultra-modern, spacious parking facility on to medieval defensive architecture. As the Duke envisaged it, the stylistic lexis of the 'High Middle Ages' was to form a 'skin' over a modern amenity – and this in the latter half of the 20th century. Featuring simple building elements in an astringently economical stylistic idiom, a monumental structure took shape in the plans. The arrangement and use of various different types of

buildings and forms of defensive architecture was in turn intended to produce a complex that looked historic. A plan dated 1968 envisages enclosing the area to the north of the north terrace of the main building by erecting a new wall replete with watchtowers, which would have closed the last gap in the wall. There were also plans for another extensive remodelling project: enlarging the wall to the east into a sort of outer courtyard, starting at the east wall.

A round tower like a bastion was to be built on the terrace area in front of the kitchen tract. All the feverish activity involved in driving forward such a welter of diverse plans and continually extending the boundaries of the complex looks manic indeed. The ideas for more buildings on the Ringberg had developed such a dynamic of their own during Duke Luitpold's lifetime that they became virtually intractable.

82 *Design for a large, modern garage in the guise of a medieval barbican south-west of the Ringberg Castle enceinte. Unrealised project, drawing, 1968, Heinz Schilling*

#		#		#			
1	Main building	6	Summer House	15	South-west portal	—	1914–1919
1a	Vestibule	7	Chemin-de-ronde	16	South tower	—	1920–1929
1b	Observation tower	8	Terrace of Destiny	17	Crenellated south wall	—	1930–1939
1c	Inner courtyard	9	Garden Hall	18	Garden	—	1940–1945
1d	South terrace	10	Arcade	19	East wall	—	1945–1958
1e	North terrace	11	Birthday Tower	20	Swimming pool	—	1958–1973
2	Guest Tower	12	North wall	21	Cistern Tower		
3	Gatehouse Tower	13	West wall with the chemin-de-ronde	22	Ancillary buildings and bowling alley, torn down in 1983		
4	Hermitage	14	Urn alcove	23	Planned car park		
5	Chapel						

83 Ringberg Castle. Layout showing the building phases of the entire complex until 1973

From 'Ansitz' to 'Fortress'

84 Ringberg Castle. The entire complex seen from the north-east in an aerial photograph taken in 1985

The interior of Ringberg Castle

FURNISHINGS AND APPOINTMENTS

Ringberg Castle owes its cultural and historical importance to the virtually unchanged interior of the main building with its four tracts. It was furnished and decorated primarily between 1916 and 1930. Some additions were made to the complex in the 1930s and early '40s. Duke Luitpold, who had commissioned it, had wanted to have his castle along with its furnishings and appointments completely remodelled into a 'stylistically harmonious whole' – in other words, into a total work of art. Like the architecture itself, the entire interior of the main building with all its furnishings and appointments was designed by Friedrich Attenhuber. His noble patron had most of the work done by local craftsmen. Luitpold did not purchase furniture or other appointments ready-made elsewhere (except for basic commodities and a tiled stove), nor did he make any effort to furnish the rooms with antiques. In fact, Luitpold took over virtually nothing from the furnishings and appointments he had been living with.

An excerpt from the family and business chronicles of the reputable Munich auction house Lehman Bernheimer, published in Munich in 1950, is instructive: 'Duke Luitpold of Bavaria [sic] bought his furnishings and appointments from Bernheimer. After the war [the First World War], his taste changed and he built himself an ultra-modern little castle, which he had appropriately furnished and appointed. Later [c. 1930], we bought back from him the valuables he had acquired earlier.' What is here designated as 'ultra-modern' was an eclectic taste that embraced late Historicism, Art Nouveau, Art Deco and New Sobriety.

The formal idiom of the interior accordingly includes elements of both Historicist and modern period styles. Elements of the design of some rooms and furnishings were derivative in conception, either borrowed from various medieval periods and the Renaissance or taken over as verbatim quotations. The rooms most noticeably indebted to Historicism are on the ground floor of the castle and were intended to be used as showy reception areas. Historicism was regarded as conservative at the time construction work began on the castle, shortly before the First World War, but it received fresh impetus with the emergence of a regional style that entailed a resurgence of centuries-old traditional crafts, which had been threatened with extinction by the growth of industrialisation. In reaction to the urban trend, this regional style glorified all that was vernacular and rural. This tendency informed the building of Ringberg Castle right down to the 1940s painted and drawn portraits of people from the Tegernsee area hung in some of the rooms. The furnishings and appointments and especially the overall design of the interior represent a blend of Art Deco and exuberant Art Nouveau elements. A number of rooms, on the other hand, were

85 *Friedrich Attenhuber, ceramic vase in the Red Drawing Room*

decorated in the decidedly austere style of the 1930s and '40s, which was modern for the time.

Friedrich Attenhuber was responsible for the entire interior design, including both the immovable and movable appointments of the main building. The designs and plans attest to a comprehensive artistic project for his patron and the objects actually made – which, subsequently inventoried, number more than five hundred entries – are even more revealing.

The artist first had to ask questions relating to the interior, such as the design of fixed structural building components – stairwells, the wall articulation, stucco or wooden ceilings, stone or parquet floors, fireplaces on a grand scale and sculpturally conceived tiled stoves. The walls of rooms were to be clad with wood panelling and wainscoting and decisions had to be taken on whether colour schemes were to be monochrome or polychrome and designed with stencil painting in mind. Attenhuber personally mixed the paints used for the walls of the main stairwell.

He also designed all the light fixtures and numerous other details, such as coverings for heating units, door handles, fittings and wrought-iron railings. Tapestries occupied pride of place among the textiles used in the interior and must surely have posed for the artist the biggest challenge since he also had to oversee their production at the manufactory. More on the interior-decorator level, on the other hand, Attenhuber designed carpets to match the furnishings, table runners and decorative cushions, decided on what types of material were to be used and ensured that they were appropriately dyed. This also included upholstery fabric. Designing all upholstered furnishings – from the individual colours to the fabric patterns – ensuring that they matched and overseeing their production was enormously time-consuming. However, the consistently high standards of workmanship are part of what create the exceptional atmosphere at Ringberg Castle. Luitpold encouraged Attenhuber: 'Take courage, don't put it off any longer … finish all the interior decorating as quickly as you can, then you've got it behind you as soon as possible.'

A particular focus was on ceramics, such as vases, sculpture, air purifiers for eliminating cigar smoke, dishes, ashtrays and lamp stands, all of which Attenhuber not only designed but, in part at least, painted and fired. Here his tiled stoves are particularly noteworthy: he even decorated some of them personally.

Finally, Attenhuber was commissioned to fill the castle and the grounds with works of art. He personally did

86 *Tiled stove in the dining room after a design by Friedrich Attenhuber (see fig. 87)*

numerous paintings, drawings, two large murals in the secco technique, stucco reliefs, ceramic motifs, reverse-glass paintings, bronze sculpture and fountains.

Attenhuber no doubt set about accomplishing the task not only of submitting architectural plans for a castle but also designing its interior down to the last detail with great confidence. In accepting this dual role, he aligned himself squarely with a tradition that gained momentum towards the close of the 19th century, when the status of the decorative and applied arts increased concomitantly with the emergence of the idea of the total work of art.

Furnishings and appointments

Ringberg Castle reveals itself as a spatial work of art that is virtually unparalleled in Europe. A glimpse into its interior also conveys insights into the aesthetic contradictions rampant in the first half of the 20th century. The furnishings and appointments created by Attenhuber, which have survived intact, also provide ample evidence both of the progressive stylistic trend informing the period and break with it as well as retrograde tendencies. Moreover, and this not least, a total work of art is presented here, the creation of Friedrich Attenhuber, an artist who – although not equally talented in all fields – has remained virtually unknown despite being both versatile and prolific.

The workshop movement and interior design in the late 19th century

The belief that living with beautiful things – which included hand-crafted furniture – might exert an edifying, ennobling influence originally came from England, but later was just as widely held on the Continent. The reforming ideas postulated by William Morris led to the founding of the Arts and Crafts Exhibition Society in 1888 and that same year to the realisation of the workshop idea with the founding of the School and Guild of Handicraft by the architect and designer Charles Ashbee. Centres of the workshop movement had sprung up at the same time in several Continental cities: Vienna, Dresden and, most notably, Munich. Architecture, the fine arts, the decorative and applied arts and crafts were all to be on an equal footing and, as a result, merge as one. A new dual-track professional type emerged in the arts: the painter-designer, the painter-craftsman, the painter-architect. William Morris, Henry van de Velde, Hermann Obrist, Peter Behrens, Carl Strathmann, Richard Riemerschmid, Franz von Stuck, Otto Eckmann and Bernhard Pankok were the leading exponents of this new development in the decorative and applied arts. Art periodicals made it their mission to advocate the new style. The Vereinigte Werkstätten für Kunst und Handwerk was founded in Munich in 1898. The goal of this association of workshops for all the arts was that interior design become an aesthetic whole based on the union of the artistic idea and skilled craftsmanship in harmony with function.

Numerous Art Nouveau artists viewed designing the entire living environment rather than creating individual great works of art as the task confronting their era. They strove to overcome the constraints that being forced to limit their activities to a single skill they had learnt – usually painting – imposed on their creative powers. Various social utopias informed the ideological background of the ideal total work of art that emerged alongside the workshop idea in the 1890s.

CHRONOLOGY OF THE INTERIOR DESIGN

When construction work commenced on the Ringberg, Duke Luitpold also had designs done for the interior of the castle and at times was intensely and enthusiastically preoccupied with them. He came up with one idea after another, one often overriding the other, and kept impatiently urging Attenhuber to translate them into suitable designs. In a letter dated 1 January 1914, he wrote to Attenhuber, who was staying on Chiemsee at the time: 'Come back. Every day tremendous plans occur to me – convince me of the impossibility of bringing them to fruition.' Even before the topping-out ceremony, which took place in September 1913, Luitpold was busy commissioning samples for the ceilings in the main stairwell and the hall and wanted Attenhuber's expert opinion on them.

During the First World War, the Duke was on active duty at the front. He bombarded Attenhuber with urgent requests to finish the building on the Ringberg and its interior as soon as possible: 'It's high time to finish the rooms,' he wrote from the front to his 'personal artist' at Tegernsee (letter of 1 January 1915). The Duke built his home in his imaginings, and evidently wanted to move into it immediately upon his return from the front. As the correspondence conducted at that time between Luitpold and Attenhuber shows, the Duke never ceased issuing new instructions on how the rooms were to be designed. He was probably thus projecting something of normal life into his wartime existence. Luitpold demanded that the plans for the interior, including all furnishings, be worked out in detail and also expected designs for various works of art to round off the interiors – both sculpture and paintings.

As urgent as the Duke's requests for designs may appear, his plans are neither recognisably structured nor is any continuity revealed in them. In summer 1915, for instance, although work had barely begun on the interior of the castle, he warned Attenhuber not to neglect the fountain in the inner courtyard: 'I attach particular importance to this fountain, without which, after all, the courtyard is not complete …' (letter of 17 July 1915)

87 Friedrich Attenhuber, design for a four-legged table with a hexagonal top, coloured pencil drawing, c. 1915

88 Friedrich Attenhuber, design for a little cupboard for the writing room, pencil drawing, c. 1915

Despite the suggestions and ideas with which Luitpold continued to besiege Attenhuber, he astonishingly claimed that he had 'not the slightest share in designing the rooms' – unlike the castle itself, which he viewed as his creation and no one else's. This is just one of many quirks in the relationship between Luitpold and Attenhuber.

By late 1915, or early the following year, the Duke had for all intents and purposes commissioned Attenhuber to design all the furnishings of the most important ground-floor rooms: the bedroom, the Great Hall, the dining room and the Tarot Room (Witches' Room). Except for the writing room, which had been designed along with its furnishings during the war years, work did not begin on the Ringberg Castle interiors nor were the furnishings made until after the Great War, in the early 1920s. There were several reasons for the delay. One of them was the war. There were simply not enough workmen, especially skilled craftsmen. All the men had been called up for service. 'It would be easier if there were still any craftsmen with a feeling for art left who could immediately realise their ideas and execute detailed drawings themselves – but that's just the way it is, there aren't any.' Thus wrote Luitpold in November 1915 to Attenhuber, who was evidently overworked because he had to do so much himself. Late in 1916, Attenhuber himself was called up, which for the time being put an end to his work designing furniture. He would not be able to resume his activities on the Ringberg until 1919.

In the early 1920s, commissions piled up on Attenhuber. In addition to designing the furnishings and interiors, he was constantly occupied with one new architectural design after another and had to organise what went on at the construction site and supervise it. By the mid-1920s,

Chronology of the interior design

financial straits were the worst of the problems plaguing his patron, preventing him from furnishing and decorating the rooms and indeed preventing completion of the building in general. There could be no thought of moving into the unfinished castle, which was in any case a continual construction site. Luitpold was so frustrated, he even thought of selling ' … due to being wearied by you dragging your feet for years on the most essential rooms', thus the harsh words he wrote to Attenhuber in 1926. Indeed, the interiors of the main building were far from finished; the kitchen was not in a state to be used and much of the furniture had yet to be put in place.

In later years, the uncertain political and economic climate – the key words to be mentioned here are the Depression, galloping inflation, followed by the Second World War and the post-war years – continued to delay the construction work and even threaten its completion. Moreover, differences of opinion as well as the hostility that grew ever more apparent between the artist, who had far more work than he could handle, and his patron hindered work in progress.

The first thing the Duke did was to have the main building decorated and furnished, notably the showy reception

89 Friedrich Attenhuber, design for a tiled stove (for a guest room on the first floor), coloured drawing

90 Friedrich Attenhuber, design for a tiled stove (for the sitting room on the ground floor), coloured drawing

92 | The interior of Ringberg Castle

rooms on the ground floor. Including the vestibule, the stairwell, the hall with the fireplace and the studio above the stairwell on the second floor of the tower, there were forty-six rooms together with the tower room that had to be furnished. If ancillary rooms and bathrooms are added, there were an additional twenty-two rooms, both reception rooms and private apartments, that had to be decorated and furnished as well as the large kitchen area, which included the pantry, two stairwells and corridors. Each room had a distinctive style and was probably intended to convey its own individual mood. The wall fittings, whether panelling and wainscoting, stucco and marble pilasters, mouldings and cornices articulating the walls or the chair rails and skirting boards so exquisitely coordinated with the decorative tiled stoves, which varied from room to room, are all informed by an overriding, harmonious design principle.

All furnishings and appointments bear dates and Attenhuber's signature so that it is possible to trace the decorating process chronologically. This information confirms that furnishing and decorating the ground floor was given first priority; further, that the furnishings and appointments for the pine-panelled rooms on the first floor were among the first to be finished.

The elaborate furnishings of the writing room were probably the first produced. The designs for this furniture had been worked out as early as 1916. Since the castle rooms could not be used until the tiled stoves had been installed, it is safe to assume that the writing room, the Witches' Room and the Great Hall had been finished by the mid-1920s and that these rooms – except for the Great Hall, which long remained unfurnished – had been completely furnished by that time.

In a second phase, the years 1927 and 1928, the guest rooms on the first floor were furnished and decorated. Many of the furniture designs for these rooms were earlier but could not be executed until later. Written instructions issued to Attenhuber by his patron on 6 January 1923 are informative: 'It is to be hoped that by now you have mastered the furnishings for the guest rooms or can shortly hereafter consign this second-class business to the drawers as finished and ready for orders to be placed when the state of my finances permits me to have them made?'

After decorating and furnishing the rooms, Attenhuber found some time to devote himself to painting again. Most of the pictures were probably done on commission to decorate the Ringberg Castle rooms. The 1930s and '40s saw Attenhuber complete sixteen dated oil paintings, most of which were in formats suitable for the guest rooms, although there were also neo-Romantic pictures in large formats, some of them devoted to mythological subjects, such as Narcissus and Echo in the Music Room and Daphne in the dining room. For the Spring Room on the first floor, Attenhuber painted a cycle of three pictures featuring subjects borrowed from the Youth League, or the German Youth Movement. The rooms were, however, mainly decorated with portraits of local people, most of whom had also worked on the Ringberg.

Very few changes were made in the castle's interior after Attenhuber died, in 1947. The stucco reliefs on the upper floor of the Summer House after designs by Attenhuber were not executed until the 1960s.

THE CASTLE'S INTERIOR DECORATION CONCEPT

The most important, and consequently the most elaborately designed, rooms were on the ground floor of the four tracts. The rooms for public receptions are in the symmetrically articulated north wing and the Duke's private apartments were in the south wing. The sequence of rooms in the south and east wings is repeated on the first floor.

The main room on the ground floor is the Great Hall in the north wing. The height of its ceiling establishes the ceiling height throughout the ground floor. To the east, the Great Hall abuts the Music Room and to the west the dining room. Double french windows between two large windows open on to the loggia on the north wall of the hall, with the north terrace along the façade.

The ground floor of the west wing was the kitchen tract, which housed the pantries, larders and a large kitchen. A door leads into the kitchen from the west side and the kitchen is linked via a small intervening room with the tower containing the spiral stair.

The Duke's 'private suite', with his bedroom and bathroom, was in the south wing, but it was later turned into the Garden Room. The original plan designates the three adjoining rooms (going from west to east) as 'valet's room and wardrobe', 'bedroom' and 'dressing room'; the dressing room is larger than the bedroom. The bath as well as a small spiral staircase leading to the upper floor are reached via an antechamber. A door also opens from the antechamber to the writing room in the south-east corner of the castle. A loggia with four openings, accessible from the writing room, the Garden Room and the Great Hall with the fireplace, fronts the south wing.

The east wing houses two almost square 'sitting rooms', with lavatories between them. The more northerly of the two rooms was designed as a 'Tarot Room' (later called the 'Witches' Room' because of the subject matter of its tapestries). North of this room is a stairwell housing the 'Landshut Stair'.

As mentioned above, the Great Hall set the ceiling height for all ground-floor rooms, including those that are much smaller. In the latter, there is therefore a noticeable discrepancy in scale between the small floor size and the considerable room height.

The different storeys of the castle are connected by four staircases, counting the small spiral stair in the

1	Antechamber	7	Garden Room	13	Great Hall
2	Main stairwell	8	Writing room	14	Dining room
3	Hall with a fireplace	9	'Sitting room'	15	Preparation area
4	Stair Tower	10	Witches' Room	16	Kitchen
5	Corridor	11	'Landshut Stair'		
6	Former servant's room	12	Music Room		

91 Ringberg Castle. Floor plan showing the room layout of the ground floor of the main building

The interior of Ringberg Castle

Duke's 'private suite' in the south wing. The main stairwell in the watchtower connects only the ground floor with the first floor. Whereas the stairwell was intended to be showy, the spiral staircase in the small adjacent stair tower in the angle between the watchtower and the west façade was built for practical purposes. Extending from the basement to the upper floor, it links up with the upper floors of the watchtower. Staff could use it to go up from the kitchen, which has its own outside door, unhindered and unnoticed by the occupants of the castle. The 'Landshut Stair' in the east wing runs from cellar to roof, connecting all floors.

On the upper floor, there is a drawing room in the southeast corner of the upper floor above the writing room. The

- **2** Main stairwell
- **4** Stair Tower
- **11** 'Landshut Stair'
- **17** Vestibule
- **18** Former servant's room
- **19** The Duke's bedchamber
- **20** The Duke's bathroom
- **21** Red Drawing Room
- **22** Guest rooms
- **23** Pine-panelled rooms
- **24** 'Spring Room'

92 Ringberg Castle. Floor plan showing the room layout of the first floor of the main building

The Castle's interior decoration concept

'private suite' on the ground floor is echoed by an identical suite of rooms on the floor above, in which the ducal bedroom and a large bath were later accommodated.

In the east wing, the lavatories, bathrooms and cloakrooms between the two sitting rooms are accessible from both of these rooms and the hall. According to a plan submitted in 1912, the ancillary rooms did not give on to the passage so that a hotel-like closed suite of rooms would have been created.

The first storey of the north wing comprises four rooms, which the original plan designates as 'guest rooms'. The rooms in the north-east and north-west corners are the pine-panelled rooms. Each of them has an adjacent room with which they share lavatories.

In the west wing, a suite of sorts comprises three adjacent rooms, with a lavatory. The functional term 'sitting room' appears twice on the plan, whereas the smaller room to the south is designated as an 'ironing room'. That is the room in which Attenhuber is said to have 'housed' at times.

The second floor was not added until after 1947. The rooms on it were reserved for 'guests and staff'. These rooms were finally remodelled and decorated as modern guest rooms in the 1980s.

On the ground floor of the south wing, the Duke's private apartments and his writing room formed a 'suite', a sequence repeated on the first floor. The ground-floor rooms in the south and east wings as well as those on the entire upper floor are arranged following a simple paratactic principle.

The rooms so often designated 'sitting rooms' usually have one window, a door opening on to the corridor and some are linked by doors. They seem like separate apartments. On the ground floor, there is one such room but eight of them are on the first floor, all decorated and furnished as guest rooms with beds, wardrobes and seating and writing furniture. The monotonously uniform room arrangement, with the long row of doors so confusingly similar, is more reminiscent of a corridor in a hotel or a row

93 *Corridor on the ground floor with a view of the hall with the fireplace*

of cells in a monastery. By contrast, other areas in the castle are arranged irregularly, which makes them interesting to behold. This is particularly true of the entrance area, the rooms in the south-east and the ground-floor rooms in the north wing.

The arrangement of rooms at Ringberg Castle was not consistently planned throughout and can definitely be seen in the context of a house intended for entertaining as indicated by the following rooms: a gaming room (Witches' Room), a Music Room, the elaborately decorated central Great Hall, a spacious dining room and a large kitchen as well as a comfortable drawing room on the first floor. An appropriate room was available for all social occasions – from receptions to lectures and concerts to evenings devoted to gaming. Everything had been thought of to provide entertainment for guests. This is demonstrated by the presence of buildings on the grounds designated as a bowling alley, a cinema and a chapel, the rooms described above and the attention paid to the minutest details relating to lavish hospitality. Luitpold ordered: 'Buy enough silver for guests' breakfasts in Vienna or England.'

However, in the building as originally planned, only four rooms are specifically labelled as 'guest rooms'. Several questions, on the other hand, arise about what the function of the 'sitting rooms' might have been. Were they intended for the private use of the head of the house or his guests, perhaps as common rooms or as extra guest rooms, or were those rooms simply to be used as sitting rooms in the bourgeois sense of the term? They might conceivably have been intended as individual apartments for family members, but the Duke was, after all, a bachelor.

It is unclear to what use the 'suites' in the south wing were intended to be put. Why, for instance, does a spiral stair link two identically designed, complete suites on the south floor, one of which included the Duke's bedroom? Presumably the rooms adjoining the large rooms were intended for servants.

The most plausible explanation is that the interior of Ringberg Castle, which is in a remote setting in a wood, was intended to be of the hunting-lodge type. The structuring of the interior, with the rustic Great Hall and its fireplace in the lobby area, the originally austere, almost 'monastic' atmosphere created on the upper floor with its regular row of rooms and the two rustic Alpine panelled rooms below them reinforce that impression. The many hunting trophies and even the tapestries and paintings, notably the mural in the stairwell, as well as animal sculptures all revolve around the hunting theme. However, the question arises whether the Duke's ideas were really practicable. After all, the viability of the castle as a hunting lodge was never put to the test because, except for a few rare occasions, it was uninhabited and remained unfinished. The building projects carried out after the First and Second World Wars as well as those that remained unrealised were based primarily on how things would look from the outside. There was no consistent programme for the interior.

Luitpold picked the mid-1920s, just when building projects were suspended for lack of funds, to have new plans and projects for remodelling and refurbishing the castle submitted. He mulled over building towers in the south-east and south to house rooms replete with 'baths and water closets' and, most importantly, provide for large windows with low parapets to ensure broad vistas.

Those refurbishment projects were never realised; it is all the more remarkable, therefore, that the rooms in the main building survived intact with their furnishings and decoration, except for the Duke's bedroom on the ground floor of the south wing, which was converted into the Garden Room, the hunting room that was installed in the north-east round tower and the studio in the watchtower, which was turned into a library in the 1960s.

A TOUR THROUGH THE CASTLE

The ground floor
Staging receptions

The main entry area is marked by two quite disparate structures: a vestibule and a tower. Visitors to the building first enter a vestibule (or foyer), with rooms going off it on both sides. With its late medieval-style groin vaulting with brick keel ribbing, the room looks quite old. Double doors lead into the tower area, first into a small antechamber with groin vaulting and then up three steps to the main stairwell, a hall of almost 'Baroque' proportions, which is dominated by the monumental staircase. The stair leads in three flights with two landings clockwise round the room. The steps and the heavy railing with its Romanesque-style banisters forming an arcade-like structure were hewn out of sand-coloured stone. This structure was probably modelled on the outside stair of the Bavarian State Library in Ludwigstrasse, Munich, designed by Friedrich Gärtner. The Ringberg Castle stairwell is lit by two round windows, one above the other, on the south-east wall and a round window on the north-west wall. On the upper floor, the stair ends in a vestibule that opens towards the stairwell in three arcades.

94 *Friedrich Attenhuber's large mural dominates the main stairwell.*

The interior of Ringberg Castle

The high stairwell walls are rendered in a golden ochre tone and finished off at the top with a broad decorative frieze. The colours of the walls are carefully modulated and correspond to the various tones of the decorative wooden ceiling, which boasts exquisite intarsia in several woods depicting circles and squares. In fact, much of the ground plan and the decorations in the main building is based on the square and the circle. Is this fortuitous, or does it represent a deliberately geometric symbolism?

The rear stairwell wall is dominated by a large square mural measuring 4.5 metres a side, Ludwig Wilhelm and Luitpold, Dukes in Bavaria. (fig. 29) Friedrich Attenhuber painted it in the secco technique in 1926. The mural represents Luitpold's relationship to his castle and his family: Duke Luitpold (right) is depicted with his cousin Ludwig Wilhelm (left) on a level clearing on the Ringberg. Below them in the valley spreads Tegernsee; on the slope below them is an idealised view of Ringberg Castle with the belvedere tower it had at the time, the gatehouse and the Guest Tower. Attenhuber evidently had a lot of trouble with this picture. His patron wrote to him in a rage after three years had still not seen it completed: 'If the scaffolding is still standing in the stairwell in October, a wayside shrine inscription will be painted … on the wall instead of the fresco. Even it … has its limits. This summer is the final deadline that my hitherto inexhaustible patience will grant you.' (letter of 10 July 1926)

Behind a lofty segmental arch, a hall with a fireplace, designated in the original plan as a 'vestibule', adjoins the stairwell. This area, on a virtually triangular ground plan, occupies the south-west corner of the building. It leads to a cloakroom (later converted to accommodate a lift), the tower with the spiral stair, a corridor and, in the south corner, the entrance to the loggia.

This hall is dominated by a remarkably large, old-looking fireplace (fig. 96) that occupies the entire height of the room. Its lofty over-mantel is decorated with a painted medallion depicting a snipe in a stylised landscape and the banderole around it bears the inscription 'Schnepfenluk', meaning a snipe hide. The dark-wood ceiling is decorated with a diaper pattern.

The rustic, late medieval atmosphere of this room is underscored by a large cupboard with two round-arched doors, with powerful wrought-iron bats and padlocks, rather like a sacristy cupboard made of unstained wood in a simple, rustic style. Two carved stag heads with applied racks of antlers are intended to create a hunting-lodge atmosphere, which is enhanced by a large tapestry de-

95 Friedrich Attenhuber, mural in the main stairwell, Ringberg Castle as an idealised vedutà (detail), secco technique, 1926

picting St Hubert, the patron saint of hunters. The tapestry is Romantic in feeling and style, rather in the tradition of Moritz von Schwind. St Hubert is depicted encountering in a rocky landscape a mighty stag with a crucifix between its antlers. Astounded, his hands folded, the hunter stands before the blinding vision, his dog cowering beside him. The saint is clad in medieval attire. Following the Romantic notions of such garb prevalent at the time, the painter has dressed the figure in a short-belted doublet, hose and top-boots, with a hunting horn and quiver suspended from his belt; a crossbow lies on the ground to the right. The background is painterly; details stylised in the verist manner, such as large leaves and a fern in the Art Deco style, occupy the foreground.

This is the first of the fabulous bespoke tapestries made after designs by Friedrich Attenhuber for Ringberg Castle to be encountered on this tour. Produced in 1941, it is, however, a relatively late work in the series. The significance of the tapestries at Ringberg Castle is discussed elsewhere.

The Garden Room

Going from the hall with the fireplace to the south wing, past what was once a servants' room, you reach the Garden Room. As mentioned above, this was once the Duke's bedroom, with an adjacent dressing room. The room was converted to its present use in 1961.

96 *The hall with the fireplace on the ground floor*

The interior of Ringberg Castle

97 *The hall with the fireplace. Rustic furnishings in the vernacular style in natural-coloured wood and hunting trophies convey a hunting-lodge atmosphere.*

A tour through the Castle

An elongated rectangle, this large room opens through two large french windows on to the loggia on the south side. The room's barrel vaulting is clearly a stylistic quotation from the Italian Hall in the 16th-century Landshut City Residence. The keynote of the colour scheme is lime green, which lightens the vaulting, the coffering of which is picked out with strips of white stucco. The walls are clad with light-grey stucco marble panelling articulated by reddish brown and greenish black marbled streaks. A decorative frieze of a stencilled floral pattern and sprays of ivy interspersed with individual, stylised water lilies frames the walls just below the ceiling.

Two domed, light-green tiled stoves perfectly match the design of the room. The upholstery on the furniture and a matching table runner hand woven in the tapestry technique is decorated with a green and dark green diaper pattern, which recurs in various rooms.

The writing room
The Duke's writing room occupies the south-east corner of the ground floor. During the summer of 1915, Luitpold had spent a great deal of time musing on it. The writing room is one of the most stylistically consistent and substantially furnished rooms at Ringberg Castle, and is otherwise untypical of the castle interior as a whole.

Typologically, this room has affinities with the public reception rooms as they were in the transitional stage from Ansitz to fortified castle. Those interiors with their heavy furniture contain borrowings from the Gothic period of around 1500. However, oriental influences and Art Deco elements have also been added to the eclectic stylistic mix.

The writing room is so structurally complex, with an irregular, polygonal ground plan, that it is difficult to take in at first sight. Next to the entrance, the wall is slightly curved; a high, round arch on the west wall links it with a corner room that in turn leads into the loggia.

With its irregular ground plan, the writing room is one of the few rooms at Ringberg Castle evocative of 'living architectural history'. The impression intended to be created is that it is from an earlier era than the regularly structured rooms in the rest of the main building. An overarching design borrowing from the late Gothic style is overlaid with structures recalling the Château de Gruyères (figs. 81, 124) in Switzerland, after which Ringberg Castle was 'modelled'. There is also a link with the main rooms of the New Palace at Darmstadt, which Ernst Ludwig, Grand Duke of Hesse, had decorated in 1897/98 by the British architect Mackay Hugh Baillie Scott, making it the first interior in Germany to be appointed along Arts-and-Crafts lines. In Darmstadt, too, Historicist elements such as beamed ceilings, medieval-looking fireplaces and walls articulated in two zones were employed in an overarching, uniform design.

The wall colours played a crucial role in the concept of the Historicist interior. As early as 1915, Luitpold had written to Attenhuber (letter of 18 November 1915) detailing his thoughts on the matter: 'As a colour scheme, brown and yellow seems more appealing to me than green – we have, after all, a decided preference for autumn colours … In any case, develop this thought further; the room will gain a great deal in warmth on account of both the door and the wallpaper and we may even be able to work out the mood of autumn leaves in the colour scheme, which might be more elegant than green, even though it is more cheerful.'

Red and green dominate in this colour scheme; the lower wall zone features diaper work in the Gothic manner, which is reiterated in the furniture as well as in other Ringberg Castle rooms, notably the dining room, where it occurs as a sort of 'spiral motif'. The upper wall zone in Pompeiian red looks like damask. The green lattice motif is repeated between the heavy oriental-looking consoles supporting the ceiling beams.

There is a fireplace on the right, next to the door. The chimney-breast sports the Duke's coat of arms and two magnificently adorned helmets. The painting bears the inscription 'F.A. 1924'. In addition, a green tiled stove along Alpine lines stands in the room. Here it looks like a modern heating unit that was installed later. This eclectic pairing – fireplace and tiled stove in one room, seemingly dating from different periods – is encountered in many Ringberg Castle rooms.

The 'Moorish-looking' oak swinging doors reach two-thirds of the height of the round arch leading to the loggia. The door is designed with a tripartite ogee arch. Luitpold's notes reveal that he had been thinking about the design of this 'harem window' as early as 1915. He saw its form as a link with a trip to Egypt he had taken with Attenhuber in 1908/09 – '… had to think of the museum in Cairo'.

The first furnishings to be finished must have been those in the writing room – designed in 1916. According to a schedule drawn up by Luitpold late that year, the furniture was supposed to have been ready by Easter 1916. Stylistically, this furniture looks early. It is much more Historicist in character than the furnishings of other, later rooms.

Friedrich Attenhuber must have been somewhat daunted by the challenging task of designing the furniture, work that was unfamiliar territory to him. Luitpold tried to

98 *The Garden Room. Originally the Duke's bedroom, it was converted to its present function in 1961*

encourage him, albeit with an unmistakably ironic undertone: 'Other great masters of other periods also designed beautiful furniture; consequently, you, as a really great one, should be able to do it, too.' (letter of 21 October 1915)

A massive, free-standing desk in the south-west corner with a matching chair dominates the room. It looks architectural in design – articulated in three zones with prominently projecting avant-corps at the sides. These massive furnishings may look Gothic in style yet they are modern for their time in being monumentally outsized – 'like Cyclopses' (Alfred Lichtwark); details reveal a prevailing Art Deco influence. Two large buffets with 'two-storey' superstructures featuring glass doors, two small cabinets, two heavy leather armchairs with a small chess table, three magnificently carved high-backed armchairs and a bench in front of the tiled stove round out the furnishings in this

99 *The Duke's writing room. The room setup is the earliest of the castle.*

100 The Duke's writing room. A Moorish-looking swinging doors open on to the loggia.

room. The blocked decoration – some of it can be interpreted as an ivy motif – recurring on various furnishings and appointments – was carved in a late Gothic bas-relief chip technique that was revived during the Arts and Crafts movement.

The two table lamps set on a club-shaped ceramic shaft, the large painted covered vases on the little cabinets and the electric air purifier set the tone for the idiosyncratic style Attenhuber created for the ceramic objects placed in various other rooms. They are characterised by their simple, basic shapes, strong colours and bold monumentality.

The grand chandelier with brass shades suspended from the ceiling on a wrought-iron Art Deco construction recurs in other rooms.

The Great Hall
Whereas the Duke's sumptuously appointed private apartments were in the south wing, the north wing housed the rooms for social activities. Here the Great Hall was the focal point. The north side opens on to a loggia – a later addition – through double balcony doors and two windows set oddly high. The windows on the south side, which also boasts a loggia, open on to the inner courtyard.

Articulated in the stringently austere classical manner, this room is Historicist in design, representing a conscious borrowing from the Neoclassical style.

The walls of the Great Hall are articulated by a clear arrangement of greyish blue marble pilasters that stand out against walls painted salmon pink. A flat, greenish black marble socle runs round the entire room, also tying

101 The Great Hall. In this photograph, the room, with its parquet flooring, was still furnished as a drawing room. Tapestries with stag motifs cover the north windows (right). Photograph, 1980

in the soffits of the four entrances and the rear wall of the fireplace. The Great Hall is crowned by a dark brown frieze with gold decorative elements. The coffered larchwood ceiling is articulated by heavy beams in elongated rectangular fields, which in turn are subdivided diagonally into black and reddish brown surfaces to create something resembling tracery or a lace pattern (recalling swallow tails).

Like the ceiling, the design of the floor, which today is protected by a carpet, is very elegant. The parquet flooring features oak, ebony and maple intarsia inlaid with a geometric calf's-tongue pattern. However, the articulation of the walls, the coffered ceiling and the parquet design are not in any way interrelated.

The narrow walls of the Great Hall are distinguished by a stringently symmetrical tripartite articulation. Each of the central fields framed by pilasters is filled by a large tapestry and flanked by doors. Although fitted out with black marble soffits and double sliding doors, the door openings are relatively low, only half the height of the ceiling. Above the doors are large stucco fields as overdoors. A frame, designed as a stylised ivy pattern executed in colour stencilling, surrounds a sconce above each door. The decorative foliate design of these wrought-iron sconce frames is silhouetted against the whole background. Four large, identical wrought-iron standard candelabra, with four candles each, stand in the corners of the Great Hall.

The dominant feature of the Great Hall is the limestone fireplace, standing higher than a person, in the centre of the south wall. The mantelpiece is decorated with a glass mosaic in the shape of a golden monogram 'L' in a green circular field. On the left-hand side is the signature 'Fritz Attenhuber'. A bronze portrait bust of Duke Luitpold, executed by Friedrich Attenhuber in 1931, stands on the mantelpiece. The inscription on it, 'Im XLII Jahr.', indicates that Luitpold was forty-two years old when this portrait was made. The two large brass raptor figures on the mantelpiece also bear the signature 'F. Attenhuber'.

The most important appointments of the Great Hall, which remained virtually unfurnished on into the 1970s, are its exquisite tapestries. The decoration of the castle interiors began with them. Luitpold attached enormous importance to these works of art and not by coincidence because in that particular field he possessed profound specialist knowledge acquired while he was researching and writing his doctoral thesis, 'Franconian Tapestries' (finished in 1922; published in 1925). Luitpold commissioned a total of fourteen tapestries for Ringberg Castle, between 1922 and 1946; most of them were made at the Nymphenburg Tapestry Manufactory. These exquisite tapestries were woven from cotton, wool and silk and indeed cost the Duke a fortune. All these tapestries were made after designs submitted by Friedrich Attenhuber. He was also charged with organising and supervising their production. It was in this connection that Luitpold sent him to Munich early in January 1922: 'I have only given the commission to the Tapestry Manufactory on condition that you supervise the work after I have charged you with the design. You are, therefore, my illustrious master, obliged to ensure that I am not laying out hundreds of thousands for rubbish.' (letter of 7 January 1922)

Today, five tapestries adorn the Great Hall alone. Two further tapestries with stag motifs, which are now hung in what used to be the studio in the main stair tower, were also originally intended for the Great Hall and were supposed to cover the north window. The earliest of the tapestries, these two were made in 1922/23. They were evidently modelled after depictions of stags and other motifs in a

102 Friedrich Attenhuber, brass eagle and bronze bust of Duke Luitpold on the mantelpiece in the Great Hall.

pp. 108/109: 103 The Great Hall. This room on the ground floor of the north tract is now used as a dining room. The east wall is decorated with a tapestry presenting the theme 'Spring'.

A tour through the Castle

104 The Ottheinrich Tapestry in the palace at Neuburg on the Danube. Brussels, 1535. This tapestry with its stag motif was made for Palgrave Ottheinrich and clearly served as a model for the Ringberg Castle tapestries.

celebrated 16th-century tapestry from the palace at Neuburg on the Danube, which is known as the Ottheinrich Tapestry. The two stags on the Ringberg Castle tapestries are presented in a composition that is identical in essentials to the Neuburg tapestry. The handling of the Ringberg stags is at once naturalistic and veristic: they are depicted in a stylised rocky landscape that is suggested in pinks and light blues to violets and are strongly outlined. Like the armorial bearings of the House of Wittelsbach at the centre, the splendid racks of antlers extend to the borders of the tapestries. The background is suggested in linear overlaid planes, green in the background and at regular intervals stylised vegetation represented by red dentate forms against a yellow ground. The dentate forms – here in yellow – are repeated on the flat, claret-coloured ground in staggered repetition to create finely reticulated diaper work. The expressive colour scheme and the forms in the background of the pictures and the borders, which are stylised, some to the extent of being purely ornamental, contrast starkly with the rather conventionally naturalistic handling of the stags.

The magnificent tapestry above the fireplace dates from 1923. The powerful impact it makes is due to its red tones, which stand out vibrantly against the salmon pink

walls. At the centre is the Wittelsbach coat of arms: two lions on a dark ground and two fields of white-and-blue lozenges. A bright vermilion banderole bearing Luitpold's motto, 'With the times', appears above the armorial bearings. The ground of the tapestry is dark blue; over this, roses climb a trellis to cover the entire surface with blossoms and leaves picked out in bright greens shading to yellow. The roses – handled in an extremely decorative manner – are white in the upper centre of the picture and, in the lower centre, claret with a blue tinge. The trellis also represents the picture frame, which is in turn enclosed by a border with a claret-coloured triangular frieze on a strong pink ground; in each corner, a curvilinear 'L' is discernible. A vibrant light red outer frame surrounds the bottle-green and dark blue framing border.

Two large-format tapestries adorn the narrow sides of the Great Hall. They date from the 1930s and are thematically interrelated: on the east wall The Nymph, an allegory of Spring; on the west wall, The Hunter, an allusion to Autumn. In the Spring picture, a nude female figure is seated on a rock in the water, like a Nereid, and gazes at a chaffinch perched on her left hand. The picture plane is dominated by a landscape, an eclectic combination of both naturalism and verism. A riverine landscape in the

105 Tapestry with stag motif, dating from 1922/23, in what is now the library in the stairwell tower

A tour through the Castle

the overall colour scheme. The Spring picture is notable for its more upbeat palette: more blues and even white. The Wittelsbach armorial bearings are discernible below the upper border of both tapestries.

The last two tapestries created for the Great Hall date from 1946 and have been hung on the south wall above the windows. They are entitled Three Birds with Larch Branch (right) and Three Birds with Fir Branch (left); in each of them, three raptors are depicted with a pronounced realism. The background in intense red and yellow flares up like a burning horizon. The birds on their bare branches seem to belong to an apocalyptic scene.

Duke Luitpold was unstinting with funds for the tapestries and wall decoration of his Great Hall. However, he never got beyond the 'skin' – the walls and their hangings, the fireplace, the ceiling and the floor. The room was hardly ever used because it was left unfurnished. Today the Great Hall is a dining room. Chairs and tables inlaid

106 *Tapestry (1923) with Duke Luitpold's motto, 'With the times', above the fireplace in the Great Hall*

foreground leads up into a wood and mountains, in which examples of endemic flora, birds and fishes are depicted. The flora is, however, rendered on a noticeably larger scale than the fauna.

A hunter, his gun leaning against his left knee, accompanied by his dog, occupies the centre of the Autumn picture on the opposite wall. Behind him rises a steep rock, at the top of which appears a chamois. The rest of the image is also densely populated with endemic fauna – a roebuck, a fox, a badger, a woodpecker, an owl and many more animals – as well as assorted flora. Attenhuber executed his designs from naturalistic models. The way he approached his work is documented by a photograph taken in 1935, in which a young man, clad as a hunter with his gun, is sitting for him. Attenhuber translated the motif virtually verbatim. In the Autumn picture, fall colours are the dominant feature: reddish brown, green and yellow as well as reds shading into purple. The colours are finely attuned to

107 *Friedrich Attenhuber, Jakob Kössler dressed as a hunter, photograph from 1935, draft for the central figure in the 'Autumn' tapestry*

The interior of Ringberg Castle

108 *'Autumn tapestry' in the Great Hall, 1939*

A tour through the Castle

with intarsia were made after original designs for the former dining room.

Rooms within the avant-corps projecting from each end of the façade abut the Great Hall to the east and west. Doors on the narrow sides of the Great Hall lead into these rooms. They are identical in plan: after a sort of antechamber, with a tiled stove in it designed to complement the decoration, comes a high segmental arch leading into a square room with two windows, each of which is surmounted by a round window.

The Music Room
The Music Room is to the east of the Great Hall. At a very early date, Luitpold was preoccupied with furnishing and appointing it; by 1914, he requested a design for the entire room to be submitted. From it, the decoration articulating the walls and the ceiling design can be reconstructed. The plan also provided for large paintings on canvas for this room. Since the studio Attenhuber was using at the time was too small to accommodate paintings on such a large scale, he was instructed to hire a larger one.

The Music Room walls are wainscoted. The wall surfaces above the wainscoting are hung with a loosely woven cotton fabric, which has also been used for the drapes concealing the door to the antechamber: turquoise, black and white stripes form a tartan pattern on a vermilion ground. The high ceiling of the Music Room is panelled with moorland oak. The individual coffers are accentuated with gilded moulding; a gilded spherical boss decorates the centre of each coffer.

Massive benches equipped with sturdy armrests between the seats are arranged on a dais around the walls. The fields of the wainscoting behind the benches look like high backs so that the bench recalls medieval church pews. The furnishings in this room were intended to elicit a meditative mood in a dignified setting.

An eyecatcher is a large painting on the south wall, which Friedrich Attenhuber executed in 1936; however, it banishes any thought of contemplation. In devastatingly strident colours, a peculiar scene is represented: a naked blond youth, half kneeling on a stone, is bending over a pool in a cursorily depicted Arcadian landscape. This Narcissus is presumably gazing at his mirror image, so self-absorbed that he does not even notice the doe that has settled down next to him to drink. On the left, a naked beauty lolls on a rock, turned towards a male figure crouching in the grass. Next to him lies a panpipes on the ground. The staffage-like figures are shown posing for a mythological scene that has been embarrassingly trivialised. To put it mildly, the allusions to Greco-Roman mythology look stereotyped and out of place in the extreme. Indeed, it is tempting to read a hint of irony into the picutre.

The dining room
To the west, the Great Hall adjoins what was once the dining room. It, too, is preceded by an antechamber boasting a tiled stove. The two-tiered ceramic body of this stove, a cylinder above a cube, is decorated with green and dark green diaper work, which recurs in the encaustic casein painting on the lower wall zone of the adjoining dining room. (fig. 86) Above it, the walls are painted lime green, articulated with ochre-coloured fields framed by white stucco. Crowned with a groin vault, this room is cheerful and bright. The chandelier suspended from the dining-room ceiling, a delicate frame supporting several little brass shades, heightens the overall effect of lightness.

The south wall of the dining room is taken up by a fireplace with a surround in red marble sporting stout, medieval-looking columns with foliate capitals in the antique manner.

On the mantelpiece stands a bronze, a graceful rendition of Diana the Huntress. A naked female figure, so slender she looks almost androgynous, is seated in a relaxed pose on a block and looks slightly to her right. Her extended arms are crossed between her knees. A rope is wound about her ankles. The figure is encircled like a halo by the stylised rack of a twelve-pointer made of thick sheet brass. Between the tips of the antlers, a crescent moon is suspended from a thin wire in such a way that it seems to be hovering above the head of the goddess. Friedrich Attenhuber created this lovely work in the 1920s. The painting in the antechamber, dating from 1943, depicts Daphne being transformed into a laurel tree to flee the hunter pursuing her. It is difficult indeed to attribute these two works to the same artist, even though two decades and a great deal else lie between them.

The 'Landshut Stair'
Leaving the Great Hall by the inside door on the east side, one enters a passage to arrive at a door, which does not – contrary to what one might expect – lead to another room but rather to a small stairwell, which accommodates the staircase known as the 'Landshut Stair'. Here, there is also a portal on the east wall that leads to the outside.

This idiosyncratic stairwell is modelled on the Fool's Stair in the Italian Annexe at Trausnitz Castle in Landshut. Dating from the 16th century and Italianate late Renaissance in style, that structure is famous primarily for

109 The Music Room. The massive benches along the wall look like medieval church pews. Above the wainscoting, the walls are hung with hand-loomed cotton cloth.

110 The dining room. A Friedrich Attenhuber's statue of Diana graces the mantelpiece.

The interior of Ringberg Castle

its murals; what was borrowed from it for Ringberg Castle, however, was its noble construction. In a small, square stairwell, the stair winds up past landings, connecting the floors. The staircase is delimited from the stairwell by rising arches, each supported by two column-like marble pillars boasting ornamental tori. The ceilings over the flights of stairs feature barrel vaulting, whereas groin vaults soar above the landings.

The Witches' Room
The room adjoining the 'Landshut Stair' in the east wing is the Witches' Room. This room was intended for informal social gatherings and decorated accordingly. Luitpold's guests were intended to assemble here for enjoyable evenings spent in a convivial round of gaming and conversation, seated at big rustic tables, on which large lamps with shades covered in brown cloth emit a pleasantly diffuse light. In the early planning stages, the Duke spoke of this room as a 'Tarot Room', for which he desired appropriate furnishings: 'Should you design seat furnishings for the Tarot Room, bear in mind that cards will often be played for several hours in them – so they must be extremely comfortable – one must be able to sit on a soft cushion and be able to lean back.' (letter of 2 August 1915 to Attenhuber) The entirely panelled and wainscoted walls of the room and a floor of planks enhance the cosy mood created in this room. The tiled stove with its exceptionally fine foliate decoration in bottle green on a black ground is the sole antique in the castle. It came from Tyrol and dates from the latter half of the 17th century. This room was later called the Witches' Room, after the magnificent tapestries featuring images of witches in flight on various animals and objects, such as broomsticks, with which the walls of the room are decorated.

The tapestries in the Witches' Room are among the most original and impressive of all those Attenhuber designed for Ringberg Castle. Six tapestries were hung round the walls in the Witches' Room. Except for one tapestry, which has, unfortunately, been lost although it has been possible to reproduce it, the cycle has survived intact. All these tapestries are signed by the artist and marked with 'MG' in a circle, a monogram indicating that they were made at the Nymphenburg Tapestry Manufactory in Munich. Stylistically, the first five tapestries are closely related to each other and date from the 1920s, whereas the most recent tapestry, woven in 1933, is in a very different style indeed.

On the first tapestry, a witch on the left is painting round spirals and the artist's initials, 'F.A.', on the back of a doe kneeling before her. The body of this witch is covered with a calf's-tongue pattern; her bottom is decorated with circles enclosing a six-pointed star (possibly a combination of the circular sun sign and a hexagram). The second witch, who is also 'clad' in a calf's-tongue pattern, is depicted lying prone on a rock, engaging in dalliance with an amorous billy goat. Next to her lies a witch's broomstick. The scene is set in a mountainous landscape on a meadow dotted with stylised crowfoot and lilies of the valley: after all, Walpurgisnacht (Beltane, the Celtic May Day festival) is the night of 1 May. Red stars are strewn across a velvety sky.

The next, principal tapestry in the cycle, Flight of the Witches on the Ringberg of 1924, features the motif that subsumes the entire decoration scheme of this particular room. Like the better-known Blocksberg, the Ringberg is regarded as a witches' hill, where all manner of mischief erupts during Beltane. Whereas the first witch seems to be frightened enough to keep her stag on the ground, the second witch, mounted on a chamois, is about to leap eagerly forwards to join her two companions who are already flying through the sky, riding a fox and a stag, to flee a storm-lashed Tegernsee. Behind them rise up three mountains against the night sky: on a smouldering red rock on the left burn the flames of Hell, round which two devils are dancing; on the second is Ringberg Castle – the pointed helm roof of the belvedere tower stands out against a round moon face – and on the adjacent hill the Guest Tower is recognisable. The Wittelsbach armorial bearings hover between the two towers. The four sorceresses look very much alive, dressed in skin-tight patterned frocks. In the picture, specimens of endemic flora known for their variously therapeutic, toxic and aphrodisiacal powers are depicted: a tall Turk's-cap lily, a yellow foxglove and a lady's slipper below the chamois. The second witch holds a spray of mistletoe, the fourth a yellow gentian. A capercaillie (wood grouse) is flying between the chamois and the fox. At the top right is an owl with a snake; bottom right crouches a frog, showing a small tablet bearing the signature 'F. Attenhuber', bottom, right and, to the right of it, the date '1924'.

The third tapestry features a brace of witches: a gnarled old hag in a jovial mood is riding a wild boar while a comely young witch, starry veils billowing around her in a circle and ivy in her hair, is flying after a boar, holding fast to its tail. The old hag is cheerfully brandishing a broomstick and on they fly under the starlight over giant silver thistles and past a Daphne mezereum shrub.

Visualising Beltane as celebrated on the Ringberg gave Attenhuber a rare opportunity for staging a carefree,

111 The 'Landshut Stair'. The celebrated Renaissance stair at Trausnitz Castle in Landshut was the model for the Ringberg stairwell.

The interior of Ringberg Castle

112 The Witches' Room. The panelled walls are hung with a tapestry cycle entitled 'Flight of the Witches on the Ringberg'.

A tour through the Castle

113 The 'Flight of the Witches on the Ringberg' tapestry. The tapestry was woven in 1924 after designs by Friedrich Attenhuber. The Ringberg and the Castle are depicted at the centre.

exuberant spectacle and thus developing an underestimated side of his artistic talent – humour, imagination, cheerfulness, playfulness, ecstasy and free-ranging pictorial inventiveness – qualities for which he would otherwise find little scope while designing the interior of Ringberg Castle. Composition and format are adroitly interrelated in these pictures. The naturalistic, albeit somewhat schematic handling of the female figures, flora and fauna, is blended with stylised decorative patterns, such as waves rendered as a repeating calf's-tongue pattern, stars represented as simple crosses and the witches' garb evoking geometric decoration to produce a taut, dynamic composition, the impact of which is heightened by an expressive palette. Pictorial elements, such as the flowers and animals borrowed from the canon of medieval tapestry-making, have here been, at least in part, translated into a decorative, Expressionist mode.

The witch tapestries are among Attenhuber's most successful works. Intention, content and form are not only fused into a convincing whole here, but are also vehicles for an unusually high quality. They showcase stylistic devices characteristic of Expressionism and Art Deco – in the last tapestry, however, the kind of naturalism favoured in the Third Reich. Finally, it should be noted that these tapestries were worked with consummate mastery.

The 'sitting room'

The Witches' Room abuts a room in the east wing that is designated a 'sitting room' in the building plans. In its clarity of design, it represents a prime example of the stylistic transition from Art Nouveau to Art Deco. A great deal of attention was lavished on the colour scheme. Above a brown lower zone, the walls are decorated with a regular trelliswork pattern in yellow and brown, executed in stencilling. A two-tier stove in yellow tiles and greenish yellow edging, with 'F.A. 1926' inscribed on a corner tile, is subtly attuned to the colour scheme of the room as are the yellow conical shade of the tall standard lamp and the case of the clock on a small corner shelf.

Designed according to an overarching concept and in a modern style, the room provided the basis for the furnishings and appointments of similar rooms, on the first floor.

114 'Flight of the Witches' tapestry after a design by Friedrich Attenhuber

The first floor

The Duke's bedchamber

Luitpold's bedroom was, as has been mentioned before, originally on the ground floor of the south wing but was moved to the first floor in 1961. From here, there is an enthralling view of the Alpine scenery.

The Duke's bedchamber is like a stage set. A box bed with massive consoles, flanked by bedside tables, rises above a lofty wooden platform. The 'bed proper' rises incrementally from a low blanket box at the foot of the bed via the bed itself to the gabled headboard, which is designed to resemble an altarpiece retable so that the whole looks more like a royal throne room.

The walls of the room are panelled in spruce and walnut, with exotic woods forming a honeycomb pattern. The decoration and articulation of the panelling is repeated in

115 The sitting room. The mantel clock and a porcelain owl on one of the corner cupboards

116 The sitting room. The walls decorated with stencil painting, the tiled stove and the rest of the appointments are meticulously colour coordinated.

A tour through the Castle

the bed frame so that the furnishings and wall decoration form a unit.

A door leads to an ensuite bathroom, which is even larger than the bedchamber. The lower wall zones are clad in ochre-coloured, polished marble surmounted by large square tiles. The appointments of this room, including a bathtub with a tile surround, a washstand and toiletries table with Carrara marble tops and, most notably, stringently austere bespoke wall lighting in the form of 'carriage lamps', exemplify elegant Art Deco design.

The Red Drawing Room
In the south-east corner of the first floor is a large room, with an irregular floor plan corresponding to the writing room below it. Its furnishings – five armchairs, a chaise longue and two massive wing chairs, all covered in red – gave rise to the name Red Drawing Room. The fully panelled oriel window and the ceiling as well as the furniture upholstered in red make the room glow in a warm light. The walls facing the oriel window are, on the other hand, rendered. Seen from this side, the room appears stringently austere and unmistakably 1930s in style. The other furnishings – a little cupboard, a small desk and two shelves – have been developed out of basic geometric shapes and, if at all, very reticently decorated. The stove, too, has a basic cubic form. Its tiles are accentuated by a simple latticework pattern in aubergine and blue on a white ground.

The large fireplace is the attraction here. The chimney-breast boasts a picture hand painted on tiles. Attenhuber painted a 'Flute-player' motif here, a half-naked youth playing the flute in an evocative landscape. Attenhuber also painted two pictures – Bull and Cow and Stag and

117 The Duke's bedroom. The monumental bed rises like a throne.

118 The Duke's bathroom. This spacious room is a choice example of an Art Deco interior.

Doe – next to the fireplace on tiles. They are dated '1935'. Above the single shelves hang small reverse-glass paintings of birds and squirrels.

The Spring Room
The room known as the 'Spring Room' on the first floor of the north wing was furnished and decorated at about the same time as the Red Drawing Room. A window and french windows on the north wall open on to a loggia. Although no direct sunlight falls into the room, it radiates brightness and light. This effect is due to the lime green of the walls. It forms a pleasant contrast to the dusty pink cornice below the ceiling and the cove just above it. The tiled stove with its simple decoration corresponds to the colour scheme of the walls.

The furnishings consist of an upholstered corner sofa and armchair covered in fresh mint green, a simple armoire, a double bed with bedside tables and a low blanket box. The lighting, wall lamps in clear-cut cubic and cylindrical shapes, lends a cool, classical note to the room.

In the early 1930s, Attenhuber painted three pictures on the subject of Spring for this room: Two Girls and Two Men in an Alpine Landscape (1931), A Man and Woman in Alpine Costume (1932) and Woman with Stag (1932). The first of these in particular features a motif that is linked with the Wandervogel youth movement so popular at the time: young people in carefree poses enjoying nature. The movement promoted a distinctly vernacular, nature-loving and 'wholesome' culture. Is this perhaps a key to the aesthetic that had emerged in Attenhuber's work in the late

A tour through the Castle

1920s? Like most of Attenhuber's late works, these paintings are based on stereotyped, pseudo-Romanic subjects rendered in a peculiarly striking palette.

The pine-panelled rooms
A historical influence in the Alpine style is expressed in the Witches' Room and even more so in the two pine-panelled rooms, which are decorated in the Tyrolean late Gothic vernacular style. They represent the east and west corner rooms of the north wing (above the Music Room and the dining room on the ground floor). The two pine-panelled rooms are identical in design: the walls are panelled with Swiss (Arolla) pine and articulated vertically; the ceilings are also panelled. A bench is placed in front of the domed stove, which is decorated with dark brown dish tiles and stucco stripes in turquoise as well as white stucco. A drying frame of the kind generally used for drying damp clothing in Alpine houses is placed round the stove to emphasise the vernacular character of this room. The furniture is likewise made of Swiss pine: a rustic two-door armoire with massive wrought-iron mounts and fittings, a chest of drawers, armchairs, a bench, a table and a large box bed with a wooden baldachin.

The furnishings and decoration lend these rooms a comfortable rustic air, although the subtle gradations of colour in the textiles used and the way they relate to the

119 *The Red Drawing Room. The appointments epitomise the austere style of the 1930s.*

colours of the stove also lend it considerable elegance. The dates '1920' (on the bed frame) and '1914' (on the door jambs) indicate that the pine-panelled rooms were among the first at Ringberg Castle to be furnished and decorated. Each of these rooms is decorated with hunting trophies and portraits – drawings and paintings – done in 1945/46 of residents of the surrounding villages and hamlets. The subjects depicted are named as Maria Höss, Hans Keller, Johann Schober and Elisabeth Schober. The ambience is obviously that of the hunting lodge and the panelled rooms look as if hunting parties are expected at any moment.

The guest rooms

There are several reticently decorated guest rooms – let us call them that here – on the first floor. Friedrich Attenhuber was given virtually free rein in decorating and furnishing them. The Duke regarded having to deal with furnishings as a 'second-class occupation'. What is remarkable about the 'sitting rooms' is the subtle and harmonious colour scheme informing all elements of these interiors. The hues of the walls especially reveal Attenhuber's talent for designing with colour. The stoves usually set the basic colour tone in a room. The tiled stoves, in shape and decoration individually designed by Attenhuber, are among the finest appointments: featuring a simple substructure

120 *The Spring Room. The motifs of the three paintings, executed by Friedrich Attenhuber in 1931/32, gave rise to the name of this guest room.*

121 One of the two pine-panelled rooms. The walls and ceiling of these two guest rooms are entirely panelled in pine.

and a clear cubic superstructure, they are so handsome that they represent the classic Art Nouveau tradition at its finest. Art Deco motifs and austere linear forms are reflected in their decoration. The furnishings are clearly and simply designed and many of them are generous indeed in both scale and proportion. Attenhuber reverted to the box furniture style that had been rediscovered from a functional and an aesthetic standpoint and further developed by Richard Riemerschmid before him. The structural model was simple vernacular furniture: a boarded construction with the uprights also boards, all right angles and devoid of decoration; the joint construction is exposed to view, a feature on which constructivism, for instance, is based – unabashedly visible dovetailing at each upright edge and distinctive wrought-iron hinges. The veining of the natural wood is also important; it was emphasised by sandblasting the surfaces. Prime examples of this design principle are the cupboards in the hall with the fireplace. (fig. 97)

The overall interior design of Ringberg Castle, with all its furnishings and appointments, can justly be attributed to Friedrich Attenhuber, the last Wittelsbach 'court artist'. In accomplishing what he did, the artist gave free rein to his undoubtedly great talent in creating sophisticated rooms and furniture suites, while developing colour schemes that are compositions in their own right, designed down to the last detail. However, Attenhuber was evidently not such a dab hand at designing furniture. Admittedly, the furnishings are perfectly attuned to the mood and atmosphere

The interior of Ringberg Castle

122 One of the first-floor guest rooms. The whole interior was designed by Friedrich Attenhuber.

deliberately created in each room, but as far as both form and scale are concerned, these pieces look for the most part rather homespun. Many of the works of art that Attenhuber created expressly for Ringberg Castle are, by contrast, remarkable in their own right. Still, there are others, especially the pseudo-Romantic paintings he executed in the 1930s and '40s, that are so rigidly cliché-ridden that they attest to the way Attenhuber worked himself into what was, aesthetically speaking, a cul-de-sac, a development that must be regarded as almost tragic.

The paintings Attenhuber executed before the First World War, on the other hand, represent a particular treasure trove at Ringberg Castle. They are on display in the corridors and guest rooms on the second floor, which was refurbished and fitted out by the Max Planck Society in the early 1980s. These Attenhuber paintings, which might best be stylistically classified as late Impressionist, are, with their glowing palette, painterly freshness and dynamic compositions, the life-affirming work of a gifted artist.

A tour through the Castle

Ringberg and its place in cultural history

The Ringberg Castle complex has from the outset elicited emotions ranging from astonishment, consternation, misgivings, even rejection – in any case a vehement response, be it positive or negative. Although Ringberg Castle is certainly not what is dubbed 'high art', it has nonetheless been classified as a listed historic monument under the terms of the Bavarian Law for the Conservation of Historic Monuments. Hence it has been recognised that preserving Ringberg Castle is in the public interest because of its importance in terms of history, art history, urban planning and even folklore.

The confusion that has arisen about how the complex should be evaluated is reflected in the records of the Bavarian State Historic Monuments authorities, which reveal how historic monument status was conferred but then rescinded, only to be bestowed again. As the most recent testimonial to the Wittelsbach building tradition, Ringberg Castle enjoys a special status.

This is a complex that defies immediate classification. At first glance, it looks like a conglomerate of disparate stylistic elements; upon closer inspection, however, it seems more like the sum of applied or, rather, living architectural and art history. The castle's stylistic peculiarity lies in its particular blend of Historicism and modernity. Moreover, Ringberg may well be more the product of a way of life than the 'private' monument that a duke obsessed with building might have erected to himself. The question arises, for instance, of whether this structure, which Luitpold created in collaboration with Friedrich Attenhuber, his 'private artist', is the result of particular individual notions entertained by the artist and his patron or, alternatively, whether collective ideas were also realised here.

VILLA, PALACE OR CASTLE?

It is impossible to say with absolute certainty whether what Duke Luitpold wanted to build from the outset was a villa, a castle or a fortress. Sketches of the original, 1912 building that have survived suggest either an Italian villa or a Tyrolean Ansitz. The Duke's own words to describe the complex in later years, on the other hand, argues for his having thought he was building a palace. From the 1920s, by contrast, features of defence architecture were continually integrated into the complex, which took on a fortress-like appearance.

Art historians do not clearly distinguish between a 'villa', a 'palace' and a 'castle'. The boundaries in the terminology are blurred. Indeed there are infinite variations on such buildings, which only in rare instances clearly and incontrovertibly run true to type. Any undertaking to classify Ringberg Castle according to a typology as vague as these must ultimately remain problematic because by the 20th century a villa, perhaps also a castle, could, architecturally speaking, be viewed as functional, but a fortress certainly could not.

The villa

In Roman times, a villa was the house belonging to a manor, in other words, a manor house. The type of architecture, its size and integration into the surrounding countryside were – as they are today – the result and expression of the social standing and financial means of the person who commissioned such a structure. The preliminary plans for Ringberg and the original building of 1912 are on a scale that could still be reconciled with the term 'villa'. Another important indicator that the early building was of the villa type is the fact that the ground floor was intended as the main floor and furnished and decorated accordingly.

However, the Duke, who, until the peerage was abolished in 1919, was nonetheless a member of the nobility, was probably already envisaging a castle, which would be more appropriate to the traditions and lifestyle cultivated by the Wittelsbachs, one of the oldest ruling dynasties in Europe. Regardless of whether the Duke saw himself as building a villa or a castle, it can be confirmed that the original structure, in respect of scale especially, was indistinguishable from the showy upper-middle-class villas typical of the 19th century and revealed borrowings – at least some elements – from the Alpine Ansitz and even more so

from Italian and Tuscan villas. A contemporary picture taken from the south of that early, still two-storey structure with the covered belvedere makes this clear. (fig. 49)

The palace

The palace, erected by the aristocracy, developed from medieval castles without fortifications and from ostentatious city residences, and is a revival of the 'villa' in Classical Antiquity. The distinguishing features of a palace are showy façades, spacious ground plans, magnificent appointments and landscaped grounds. Recurrent elements are the cour d'honneur and the grand stair outside and enfilades, vestibules, showy stairwells and fireplaces inside. Many of these elements are likewise encountered at Ringberg Castle.

Since Luitpold was a member of the aristocracy, it would seem appropriate to classify the complex as a palace, regardless of the imposing fortress elements. Biederstein was once Luitpold's city residence; Ringberg would have been his hunting lodge. Indeed it embodies both in its location in a hunting preserve and in its design – the closed structure of the original building, the number of apartments, the Great Hall as a common room and the watchtower – features typical of a hunting lodge. This evaluation is confirmed by a number of details: 'hunting rooms', furnishings and appointments that are, some at least, rustic and vernacular, large fireplaces, hunting trophies on display and the many hunting scenes depicted throughout the interior.

The castle

The castle is a fortified seat of the aristocracy. This is the lowest common denominator to which the interminable discussion about the term can be reduced. In a castle, the living quarters and fortifications are on an equal footing, whereas, in a fortress, the defence capability and, in palaces and villas, the functions of living and entertaining on a grand scale take precedence.

123 Ringberg Castle, watercolour, c. 1912

Villa, palace or castle?

Leaving aside the lack of defence capabilities, Ringberg might be characterised as a mountain fortress, which has been built on an outcrop of a mountain ridge. Its glacis would be in the south near the road, where, of course, there is neither a moat nor a drawbridge. The barbican (which, according to Luitpold's plans, would have housed a parking facility) was never built. The guest tower could be viewed as being a donjon or a keep, although the stair tower of the castle building with its later crenellation definitely resembles forbidding fortification. A keep planned for a higher site was not built. Whereas the living quarters in fortresses are set high up in the protected upper storeys, most of the rooms at Ringberg, which are intended for private comfort or public receptions, are on the ground floor. In fact the interior of the main building has nothing fortress-like about it.

What does look like a fortress is the enceinte with its towers, bastions and chemins-de-ronde surrounding the entire complex. The grounds inside the wall, with their gardens, garden architecture and swimming pool, look as if they belong to a comfortable, gated stately home. This combination of protection and comfort in a grand stately home occurs in a 'fortified castle'.

There are arguments for assigning the Ringberg to each of the various types, be it a villa, a palace or a castle. Viewed from outside, the complex looks like a mighty fortress that has evolved over the centuries. At its core, in the original building, is a 1912 villa reflecting Tyrolean and Italian models. The 'Baroque' garden parterre on the south side and the elegant rooms on the ground floor that open up on to the garden are more like a castle. The ground plan with its four wings is intended to suggest that a later, more regular castle developed out of an earlier, irregular (fortified) structure. The game is repeated in the eclectic design of the interior: 'earlier' fireplaces are alongside later tiled stoves and rooms with irregular floor plans alternate with rooms boasting regular rectangular ones. The main Ringberg building completed in 1913 marks the end of European castle building, yet the way the complex continued to develop until the 1970s is uniquely anachronistic.

THE HISTORICAL BACKGROUND OF THE RINGBERG ARCHITECTURE

The quest for models in the family tradition

The unusual project of building a castle or indeed a fortress in the 20th century, even though the result would be unique both as a type and in its appearance, is unthinkable without the historical, architectural and art-historical background of the period when it was built and of those involved in the project. An analysis of the Wittelsbach building tradition and the connection with individual known models and an overview of comparable structures are what make it possible to classify the Ringberg complex.

If an 'architectural backdrop' for Ringberg Castle is to be sought, that is, buildings erected by the Duke's ancestors in the Birkenfeld-Gelnhausen line, their seats, homes and possessions – and in chronological order as well as according to topography – the Palatinate is the place to begin: at first in Zweibrücken, where the Palatinate Wittelsbachs, of which the Birkenfeld-Gelnhausen line is a collateral branch, had their family seat; and from there to Birkenfeld and Bischweiler. The topographical line leads on to Gelnhausen, then to Lower Bavaria (Landshut) and Munich (Maltese Palace); then back again to the Rhine to the Duchy of Berg (Düsseldorf, Benrath) and zigzags once again to Bavaria, specifically to Upper Franconia (Bamberg, Banz, Seehof, Bayreuth), followed by Munich (Herzog-Max-Palais), Lake Starnberg (Possenhofen, Garatshausen) and Swabia (Unterwittelsbach, Kühbach) to end at Tegernsee. There are also links to Neuburg on the Danube and Biederstein Palace in Munich. Ringberg Castle marks the end of this chronological development tracing the Wittelsbach possessions from the Palatinate to Tegernsee. The only member of this ducal line in Bavaria, apart from Luitpold with his castle on the Ringberg, to build anything from scratch was his grandfather, Maximilian, who erected the Herzog Max Palace in Ludwigstrasse, Munich. Luitpold's other ancestors were content to refurbish existing buildings.

Alongside the buildings in the ducal collateral line, which were, so to speak, Luitpold's architectural family legacy, there is also the Wittelsbach building tradition as a whole. Over eight hundred years, the dukes, electors and kings of this dynasty had numerous monumental buildings erected or acquired them, including the Residence in Munich and the royal castles at Nymphenburg, Schleissheim, Herrenchiemsee and Neuschwanstein. However, a study of the Ringburg sources reveals that Luitpold eschewed using the royal buildings as models. The first

announcement in the press that construction work was to begin on the Ringberg, that the Duke intended to build a castle modelled after Neuschwanstein Castle (cf p. 10), must have sprung from the journalist's imagination. The preliminary studies and initial projects on up to the original building as it was in 1912 show that the Duke certainly did not have Neuschwanstein in mind. Indeed, stylistically, the original building is the opposite of Neuschwanstein.

The comparison between Ringberg and Neuschwanstein may have resulted in a search for parallels in the personalities and lives of Ludwig II and Duke Luitpold since they were, after all, related to one another.

There are occasional echoes in Ringberg Castle of the buildings owned by the ducal line in Bavaria. A considerable number of quotations from the possessions of the ducal Wittelsbach collateral line and the Palatinate-Neuburg line occur at Ringberg Castle, whether Luitpold was conscious of this or not. Luitpold was presumably very familiar with those buildings and their most memorable features so that his memories of them figured subliminally at least in the designs for Ringberg Castle and influenced the artistic decisions he took.

The discernible parallels with Ringberg start with buildings dating from the era of Wilhelm (1752–1837), Palgrave of Birkenfeld-Gelnhausen, and, from 1790, Duke in Bavaria. He moved into the Landshut City Residence in 1780 and stayed there for nearly twenty years. On its upper floor is the barrel-vaulted Italian Hall, dating from c. 1542, which is echoed in the very similar barrel vault of the considerably smaller Ringberg Garden Room. Indeed, it is highly likely the Landshut Residence with its four tracts was among the models for the fortress type represented by Ringberg Castle. An unabashedly verbatim quotation is the 'Landshut Stair', which is a replica of the Fool's Stair at Trausnitz Castle in Landshut. Even the altana that used to surmount the watchtower of the main building of Ringberg Castle can be traced back to the Landshut complex. These quotations in a single building, Ringberg Castle, link the 'Italianate' Landshut City Residence with the 'Teutonic' Trausnitz Castle.

Pius, Luitpold's great grandfather, resided at Seehof, a castle placed at the disposal of his father, Wilhelm, following the secularisation of monasteries in the Napoleonic era. Ringberg Castle also has faint overtones of the Seehof fortress type.

Ottheinrich (1502–1559) of the Palatinate-Neuburg line was not a direct ancestor of Luitpold's, who was Duke in Bavaria, but was nonetheless a model and a kindred spirit. Indeed quite a number of buildings from that line evidently influenced the builder of Ringberg Castle. Whereas Ringberg may not have been directly inspired by the palace in Neuburg an der Donau, the possibility cannot be ruled out that Luitpold did draw on Grünau Hunting Lodge near Neuburg, which was finished by Ottheinrich in 1555 and boasts massive round corner towers, as a model. Friedrichsburg in Vohenstrauss, a ponderous structure with round Renaissance towers, may also have influenced the design of the Ringberg corner towers to a certain extent.

Palaces and castles built in the 19th and 20th centuries

A spate of building activity during the 19th century brought forth numerous structures that reverted to the formal canon of the castles and palaces of earlier centuries because their builders wanted them to be grand, even ostentatious. The best-known are the royal castles built by Ludwig II, which were intended to surpass the medieval-fortress and Baroque-palace types or are simply eclectic blends of several styles. Usually, however, the 'bourgeois dream of a noble castle' entailed using individual stylistic elements from the past in villas and housing complexes that otherwise featured the latest modern conveniences. Thus the 19th century in particular saw the building of any number of complexes resembling palaces and castles, which in various ways might be viewed as precursors of Ringberg. Luitpold was no doubt familiar with at least some of those buildings.

There are also parallels in the ideology underlying various takes on the aristocratic residence. Some neo-Gothic structures can be viewed as total works of art, with both the exterior and the interior marked by an overarching aesthetic concept. This is the case with Babelsberg, Marienburg, Lichtenstein and Kamenz castles. Luitpold was familiar with Pena Palace, a Historicist castle in Sintra, Portugal. Although it may not have been a direct model for either the builder or the artist working on the Ringberg, its eclectic blend of period styles definitely paralleled the approach they sought. Heinz Biehn has described Pena as a 'German castle born of the spirit of Romanticism – an inorganic conglomerate of towers, gates, bastions, chemins-de-ronde, stairs and courts with innumerable suites of rooms decorated and furnished in all styles' (Residenzen der Romantik, Munich 1970, p. 267f.). Gustav Faber (Portugal, Munich 1975), by contrast, called it a 'monstrosity of a building'.

Castles built in the 20th century did without the Historicist, usually neo-Gothic style of the 19th century, incorporating their own solutions to stylistic problems. Most of these projects entailed building villas or remodelling existing structures and contemporary forms were increasingly taken into account.

Antedating Ringberg in Bavaria, the Faber Castell Palace at Stein near Nuremberg, understandably dubbed 'Pencil Castle', was built with a Romanesque-looking exterior but an interior that is stylistically diverse in the extreme, borrowing from the 'Baroque Art Nouveau' Hirschberg Palace on Haarsee near Weilheim, the neo-Baroque Craheim complex and the palatial neo-Baroque manor house in Weidenkam near Münsing. Kranzberg Castle near Krün in the 'Scottish Baronial' style has several tracts and was built in southern Bavaria at almost the same time as Ringberg. Elmau Castle Hotel, a rectangular structure resembling a monastery, was built not far from Kranzberg. Outside Bavaria, elegantly decorated Cecilienhof Palace, designed by the architect Schultze-Naumburg, is noteworthy in the present connection. Next to the ruins and the keep of Finstergrün Castle in Lungau, which was first recorded in 1139, this neo-Romanesque castle was built between 1900 and 1905 that closely resembles Ringberg in its final form. All the above complexes are linked in some way with Ringberg, either because they were built at about the same time or they are structurally similar to it, although they cannot be cited as models.

To gain a better understanding of Ringberg Castle, one must also draw on the vocabulary of forms and the stylistic devices used in contemporaneous architecture other than grand stately homes, palaces or castles, which is nevertheless related to it. This line of reasoning leads directly to 20th-century Neoclassicism and the architect Peter Behrens. Certain notions of style and architectural forms found in his company headquarters, factories and other

124 *Château de Gruyères (Switzerland). Old postcard. Various stylistic elements of this complex inspired Duke Luitpold when he was conceiving Ringberg Castle.*

Ringberg and its place in cultural history

125 Duke Luitpold, Wendgräben Manor, undated pencil drawing. This manor house designed by the architect Hermann Muthesius was built in 1910. Luitpold's castle was inspired by contemporary as well as medieval and Renaissance architecture.

functional buildings with a claim to aesthetic quality as well as private dwellings are encountered at Ringberg, too, albeit not so pronouncedly: massive structures, cubic, flattened, sober forms, the way in which symmetry is used, fenestration and doors cut incisively into closed walls and mansard roofs. There is a pervasive tendency towards monumentalisation, with buttressing and the use of unrendered masonry contributing to this effect. It was industrial architecture before the First World War – that is, the return to familiar, tried and tested archaic types of architecture – that exerted the strongest influence on the formal idiom of castle, palace and temple architecture. The stylistic elements mentioned above were introduced before the Great War and continued to be implemented on into the 1920s and even in the following decade. They were also the determinants of the 'anachronistic' fortress-like complex on the Ringberg, especially of the building phase that followed the First World War. Here, too, high, buttressed socles of natural stone, unrendered masonry and cubic and cylindrical forms were incorporated. In building Ringberg Castle, Luitpold required his Attenhuber to work in a 'more modern' and 'contemporary' manner, eschewing anything decorative or arch and not letting 'anything actually Gothic, no pepperpots stuck on' mar the building.

In the Third Reich, drawing on the medieval canon of forms was commonplace in order to monumentalise principal buildings and to heighten their symbolic import. There is an example of this very close to Ringberg Castle, in Bad Tölz. In 1934 the first SS cadet school was built there as a facility for training Weapons SS officers. The forbidding round corner towers with conical roofs guarding the entrance to the complex, which has in the meantime been remodelled more than once, are deliberately evocative of an impregnable medieval Alpine fortress. At the Wewelsburg, which was converted into an SS Leadership School, and at the Vogelsang Educational Centre in Eifel, which was built from scratch, totalitarian claims to absolute, naked power were to be symbolised by the expressive strength of the Romanesque fortified castle.

Travel impressions

In Duke Luitpold's notes and letters, there are many references to buildings he became familiar with on his travels, architecture that exerted such a strong pull on him that he wanted to 'import' the impact they made by incorporating

them into his building project on the Ringberg. Consequently, several minor quotations from historic buildings that particularly impressed him are discernible at Ringberg.

Five years after construction work began there, Luitpold was talking about the 'Spanish, Italian and Tyrolean charm' of his building. The 'Moorish' style is mentioned as one fruit of a trip to North Africa and the Near East he took with Attenhuber in 1910. Before construction began, Luitpold had informed the building authorities at the Bavarian Association of Vernacular Art and Folklore that he had borrowed for the design of his building from the finest Ansitze in South Tyrol. That is easy to trace when one looks at such aristocratic seats as those in the Eppan region. These private dwellings, which are closed to the outside world, grew out of fortified medieval complexes whose massive crenellated towers are still standing in some instances. It is impossible to ascertain whether Ringberg was modelled after any particular Tyrolean Ansitz.

In the period between the world wars, Luitpold called the Château de Gruyères in Switzerland (figs. 84, 124) a 'beguilingly beautiful castle'. Several undated postcards of the château that Luitpold sent to Attenhuber have survived. The Duke reverted to it even after 1960, when he sent the architect Heinz Schilling there to study the building. Schilling had, again at Luitpold's suggestion, also visited Castel del Monte in Apulia to capture the mood in his design for the projected Ringberg keep. Hohenwerfen Castle (figs. 75, 76) also played a role at Ringberg, for Luitpold quoted its fortifications.

For the rest of his project to follow the main building, the Duke thought of 'roofless and unfenestrated Venetian forts like the one at Assisi [Barbarossa's hilltop fort Rocca Maggiore in Assisi, Umbria, which was rebuilt in 1367], blocks, massive bastions'. Evidently following a trip he took through the south of France, he mentioned the Papal Palace at Avignon as a model ('devoid of decoration or formalisms, colossal') as well as Crussol, Villeneuve-les-Avignon, Aigues Mortes ('walls 6 metres thick'), Les Baux, Tarascon ('unfenestrated, smooth, layered') and Lastours ('Groin vaulting in the donjon'). On the Adriatic, Luitpold was impressed with mighty fortresses in monumental cubic forms, walls with swallow-tail crenellation ('like the garden wall at Toblino' [Castel Toblino near Trento]). He was inspired by the turreted fortresses in Carinthia with their oriel windows; at Hohensalzburg he found just the model he was seeking for the corner turrets on Ringberg's north terrace. For the furnishings and appointments he drew on the 'museum in Cairo' and Tratzberg Castle. In both cases, Luitpold was enthusiastic about delicate tracery and carvings, which he had taken up in his interiors, whereas he sought forbiddingly massive forms for the external architecture.

Duke Luitpold used the wide variety of architectural forms he had discovered on his travels selectively and solely for the way they looked. According to his accounts and explanations, his 'private artist' and later the architect Schilling were supposed to be receptive to them and translate them to the Ringberg. Hence Ringberg Castle is not only in some respects 'built living history' but also a bit of the 'built recollections' of its widely travelled owner, who was an avid art lover.

Ringberg Castle – a unique ensemble in context

The above overview of antecedents indicates that both the artist and his patron of Ringberg Castle did not follow readily recognisable specific models. The castles built in the 19th century notably did not provide inspiration on which the entire project might have been drawn. Although Luitpold and his 'private artist' might have known many of those buildings, they were striving, each in his own way, for an individual, original work. Nevertheless, the Ringberg project does stand in the context of similar complexes

126 Design for the inscribed plaque on the north wall of the Ringberg Castle inner courtyard bearing the Duke's personal motto, 1960

of its day and is associated with a certain taste prevailing at the time and the stylistic form it assumed. Consequently, comparisons are legitimate and links to other buildings can certainly be made.

As shown above, the medieval fortress provided aesthetic inspiration for many building projects in the first half of the 20th century in which monumental architecture was the aim. In this respect, Ringberg Castle is unique because not only were stylistic elements of fortified architecture incorporated into it, but it is also an example of an enclosed fortified structure and was built from scratch to do so even though it had no defensive function to fulfil.

Despite the motto 'With the times' chosen at the outset, Ringberg Castle headed in the opposite direction, turning its back on modernism in favour of a growing retro tendency. Ringberg stands in a multilayered fabric of interrelated historic and modern forms of architecture and emerges from it as a special case. Nor did its owner live up to the first half of the motto 'Tempora mutantur' (Times change).

Although the Ringberg ensemble looks like an oddity at first sight, closer scrutiny reveals how uncompromisingly the reversion to medieval forms – in the 20th century – was handled here. This method was, as we have seen, nonetheless not entirely unusual. Luitpold must have drawn on forms of defensive architecture to evoke a claim to nobility and to make it appear historically underpinned. In this respect, we are back again at interpreting the building of this castle as the Duke having erected a 'monument to himself'. That the buildings on the Ringberg ultimately amounted to empty, unused shells cannot in this connection be termed a disastrous failure; after all, are there any monuments that fulfil practical functions? The Duke's original plan to build, to finish and to live in a comfortable, stately 'home' on the Ringberg foundered in an urge for fictitious self-representation and perhaps even an attempt at self-actualisation through architecture. What remains is utterly subjective architecture.

Ringberg Castle – tradition and contradiction

Having been born into the House of Wittelsbach defined a specific social identity for Duke Luitpold in Bavaria. Belonging to the nobility implied certain attitudes, ways of thinking and behavioural patterns shaped by tradition that also predestined him for a particular way of life. Thus he fulfilled the expectations society entertained for a person of his background.

In the royal patronage exercised by the House of Wittelsbach, whose members ruled for eight centuries without interruption, a characteristic attitude is manifest that was also taken up by Duke Luitpold, who continued a tradition that ended with Ringberg Castle. Letters, music, theatre and especially the visual arts were intensively promoted by the Wittelsbachs. (cf. Hans E. Valentien et al., Die Wittelsbacher und ihre Künstler in acht Jahrhunderten, Munich 1980) The fact that Luitpold was only twenty-one when he commissioned a building shows how committed he was to this family tradition. As far as his passion for building is concerned, he verifiably emulated his second cousin twice removed, King Ludwig II of Bavaria; like him, Duke Luitpold pursued the ideal of a lifetime in building a castle. Hence he wrote in a letter of 3 November 1917 while serving on the Western Front as a captain of cavalry: 'But perhaps in generations to come someone or other will look out across the countryside from the Ringberg tower and receive from past dreams of beauty the germ of a fresh knowledge of interwoven beauty, spirituality and love, which recurs constantly in the union of nature and art.'

It is right to question the extent to which the motivation for building and realising the projects on the Ringberg that the Duke pursued with such manic persistence for over sixty years was rooted in an overweening ambition he entertained as a member of the Wittelsbach collateral line to compete on an equal footing with the incomparably richer architectural legacy of the principal Wittelsbach line. On the other hand, Luitpold's attitude to his family tradition certainly seems ambivalent because he parted with family possessions such as Biederstein Palace in Munich's Schwabing district and Possenhofen on Lake Starnberg so that he might create something new and entirely his own. The Duke not only expended all his energies on attempting to realise the Ringberg project; he also depleted his finances.

The idea of building a castle started with a hunting lodge. This functional and stylistic plane was also retained, albeit overlaid with others. After the First World War, Luitpold wanted to make the Ringberg his principal residence. Contradicting his motto 'With the times', Luitpold initiated a process of 'fortification' in the early 1920s. Presumably the Duke reverted stylistically to medieval architecture for his new buildings and for those that would remain in the planning stage under the indelible impression made on him by the sudden loss of political power sustained by the Wittelsbachs – the peerage was legally abolished on 28 March 1919, although existing titles were

permitted as part of names. The interior design of the main building, by contrast, represented modern views. Regional subjects, including portraits of locals, are taken up in many of the artworks adorning the castle rooms. However, the massive swallow-tail crenellation of the south wall with the matching bastions stands in stark contrast to the imagined linkage of nature and art, of landscape and architecture, because it represents a boundary that cannot be crossed.

In a painting in the Music Room furnished with angular church pews, Narcissus is depicted bending over his mirror-image reflected in the water. The surrounding Arcadian landscape is not just rendered in a strident palette, but has also been demythologised. Moreover, this Arcadia was close to the 'metropolis'. Early in autumn 1944, bomber squadrons often flew as far as Tegernsee so that the Duke temporarily had to leave his place on the crenellated ramparts with its southern exposure to the Blauberg mountains when he was sitting, dressed in Bavarian costume, for his 'private artist' Friedrich Attenhuber. (fig. 11) The painter, who had in old age given himself the airs of a dandy, jumped from the tower. The Duke spun the yarn further by commissioning the Norns' Fountain. The elaborate landscaping of the slope took place in the 1960s, a combination of gardens and Campo Santo, where his urn would later stand.

'Tempora mutantur, nos et mutamur in illis' (The times change and we change with them) was the later version of the Duke's motto, inscribed in the 1960s on the inner courtyard of the main building. However, he consistently failed to live up to his own watchwords.

Ringberg Castle and the Max Planck Society

**BETWEEN SCIENCE AND CONSERVATION:
CONVERSION OF THE CASTLE BY THE MAX PLANCK SOCIETY**

Ringberg Castle, which was erected in the 20th century in keeping with the late Romantic spirit as a 'modern' castle with fortification walls high above historic Tegernsee, is a building that is as topographically inaccessible as it is capriciously anachronistic in style. Its builder and original owner, Duke Luitpold in Bavaria, never really lived in it. Its capacious and numerous rooms were only rarely occupied by parties of guests. In fact, as long as its builder lived, the castle would remain a deep secret to the public at large. Not until the Max Planck Society took over the legacy of this vast facility and converted it into an international conference venue for scientists was this enigmatic structure unveiled. In addition to a full conference schedule, the Max Planck Society admits the public to the complex at regular intervals as well as to a limited extent for cultural events.

PASSING ON THE LEGACY

The testamentary contract (1967)

Duke Luitpold in Bavaria, last scion of a collateral line of the royal House of Wittelsbach, bequeathed Ringberg Castle, which he had had built as his life's work and in which he had invested all the financial means available to him, to the Max Planck Society, on condition that it would be used after his death for scientific purposes and maintained in the architectural form in which he bequeathed it.

On 27 October 1967, the testamentary contract between Duke Herzog Luitpold in Bavaria and the Max Planck Society, represented by its then president, Professor Dr Adolf Butenandt, was concluded and went into effect. The contract applied not only to the castle and its grounds but also to the property surrounding it (approx.

127 The public has always been very interested in taking advantage of the opportunity to visit Ringberg Castle on Open Day, as here on 3 June 1984.

45 ha) and an entire associated package of financial instruments and securities. In exchange, the Duke was granted a life annuity.

Otto Meitinger played a pivotal role as the mediator between Duke Luitpold in Bavaria and the Max Planck Society. Then still the architect engaged in restoring the Munich Residence, Meitinger had been in close contact with Luitpold in the early 1960s, when the Duke for tax reasons considered having Ringberg Castle listed as a historic monument. To that end, he had expert reports drawn up, one of them by Otto Meitinger, who soon afterwards – in 1963 – would become director of the Architecture Division of the Max Planck Society. In 1976, Meitinger was appointed professor for design and the preservation of historic monuments at the Munich Technical University. In 1987, Meitinger was elected president of the university.

Carrying on the legacy (1973)
Following Duke Luitpold's death on 16 January 1973, the castle came into the possession of the Max Planck Society. In compliance with the donor's wishes, the society intended to place Ringberg Castle at the disposal of science and its institutes as a venue for specialist conferences, symposia and forums. The original architecture was to be preserved.

It had ultimately turned out to be advantageous in the extreme that Duke Luitpold had left Ringberg Castle as a shell. He had been primarily concerned with the overall impression made by the exterior of many parts of the building, whereas much of the interior had been left unfinished and this included the so-called Guest Tower, the old wash house and the chapel, all dating from the early 1920s, as well as the first floor of the main building and the ancillary building with a bowling alley on the north wall, which was not erected until the 1950s. The Max Planck Society had ample scope to finish and gradually convert these structural elements so that they could be re-allocated to new uses.

TRIAL PHASE (1974–1980)

Between 1974 and 1980, the Max Planck Society conducted trial runs to ascertain whether the castle would be suitable as a conference venue and what had to be done to make it so. Seminars and workshops held with a limited number of participants by the Max Planck Institutes in and around Munich indicated that both the castle's remote location and its idiosyncratic architectural style as well as the spaciousness of the facility as a whole ensured that the castle was indeed suited to such use. During this trial phase, the Great Hall in the north wing of the main building served as a lecture room. Twelve rooms, of which two were double rooms, were available as accommodation for guests in the four tracts of the main building; this meant that a total of fourteen guests could be lodged at Ringberg at that time. However, there were no other guest rooms, work rooms and gastronomic facilities that could have made feasible operations on a larger scale. When a cost estimate was submitted late in 1968 – that is, while Duke Luitpold was still alive – the general administration of the Max Planck Society realised that the castle was definitely suitable for hosting the events intended although 'not inconsiderable building measures' were needed to fully develop its potential. Even at that time, thirty-four guest rooms were factored in, that is, twenty-two more than the twelve already available.

128 Ringberg Castle. The new conference hall abuts the north-west tower.

Ringberg Castle and the Max Planck Society

CONVERTING THE COMPLEX INTO A CONFERENCE VENUE (1980–1991)

From 1980 therefore, measures were implemented for refurbishing and remodelling the facility that would take more than ten years to complete. Since Ringberg Castle had by then been listed as a historic monument by the Bavarian authorities, the conditions imposed by historic monument status had to be taken into consideration. Consequently, the Max Planck Society was also responsible for ensuring the systematic and complete inventorying of the furnishings and appointments of the main building, which – in a late Historicist vein – was still committed to the idea of the Gesamtkunstwerk, or total work of art, a commission that had to be carried out in accordance with certain art-historical considerations.

Completing the cistern

The first thing to be done was to finish the building projects that had been commissioned and begun under Duke Luitpold. Constructing a cistern was the last project on a fairly large scale to have been embarked on during his lifetime. It was planned by the architect Heinz Schilling, who had been working for the Duke on the Ringberg since 1958. Shaped like a prismatic tower, the cistern – situated immediately to the west and behind the Garden Room on the highest point of the Inner Bailey – had historical antecedents that were not atypical of those to which the Duke had recourse, given his avid interest in architecture. A keep thirty metres high and accommodating living quarters had originally been planned for the site. The ground plan would have been octagonal with pentagonal bastions. The octagonal ground plan of the cistern goes back to Castel del Monte, which was built in Apulia by the Holy Roman Emperor Friedrich II Hohenstaufen. Schilling made a trip to study it before drawing his plans. Floors with living quarters reached by a spiral stair and a modern lift were to be above the ground-floor cistern. Ludwig Abenthum, the last project director, who had power of attorney, had succeeded in dissuading the Duke from this project, for which a small model existed, because it would have overrun the budget. Clad in stone to match the structures in the Inner Bailey, the cistern as actually realised, was simple and functional although not completed until after Luitpold's death. Schilling presented the Duke, who was bedridden during his final illness, with photographs showing how construction work on the cistern was progressing.

Finishing the gatehouse and south tower (1980/81)

Construction work with the Max Planck Society now in charge commenced in winter 1980/81, starting with the Gatehouse Tower and the south tower. Accommodation for the personnel needed to service and maintain the castle as a convention venue was built into both structures. As things turned out, it was to the builders' advantage that damage sustained by the gatehouse had been repaired by Heinz Schilling back in the 1960s. Schilling had shored up and stabilised the tower by putting a corset of reinforced concrete around it. Now a comfortable flat could be built, furnished and decorated on each of its two floors. The same measures were adopted for the south tower with its sun terrace, which is linked to the gatehouse; complete restoration of the south tower had already become urgently necessary in the 1960s, when collapse had seemed imminent.

Renovating and remodelling the main castle building (1981/83)

The rejoicing over having inherited Ringberg Castle had not been unalloyed among the directors of the Max Planck Society and its administrative council. It soon became apparent that, if the castle were to be converted into a viable conference centre, considerable additional funding would be needed. Fortunately, a generous patron was found: Munich Reinsurance took their centenary in 1980 as the occasion for demonstrating their particularly close links with, and appreciation of, science and research. Munich Re donated five million DM to put Ringberg Castle in a condition that would enable the Max Planck Society to use it as conference centre for years to come.

This donation made it possible to start on fundamental restoration and renovation of the main castle building in 1981. The measures that had to be taken included finishing the first floor, which was a shell, and were carried out by the Architecture Division of the Max Planck Society, working under the close supervision of the Miesbach District Council as the local planning control commission and the Bavarian State Office for the Preservation of Historic Monuments.

In the historic building, the grand public rooms on the ground floor, such as the Great Hall, the dining room and the music room, the writing room, the Witches' Room and the Garden Room, were already in a condition suitable for use as reception and work rooms by small groups. However, a new kitchen tract with larders, pantries and administrative rooms had to be incorporated into the west wing abutting the courtyard. In fact, all technical facilities and

129 The Ringberg Castle conference centre is inaugurated by Professor Reimar Lüst, then president of the Max Planck Society, on 2 July 1983

installations had to be replaced. A modern heating system was installed. Some ceilings on the ground floor were so lofty that they had to be lowered.

Since only one bathroom existed on the ground floor and only five bathrooms were available for the guest rooms on the first floor, several of the historic guest rooms had to be fitted out with en-suite showers. The Historic Monuments Office, concerned that the subtly designed historic rooms with their remarkable furnishings might be impaired, demanded that wall plans be submitted on a 1 : 50 scale to facilitate the evaluation of the measures that were planned. The Historic Monuments Office issued detailed instructions relating to all structural interventions, the addition of heating units or shower cubicles as well as installation work '... to ensure that the historic stencil painting on the walls, the floor tiles, the skirting boards, wainscoting and ceiling friezes was not damaged. Necessary interventions were to be carefully restored.'

The Monuments Office, to take one example of the conditions they imposed, insisted on the preservation of the antique marble wash-basins that had survived in some of the guest rooms.

The second floor, on the other hand, had been left standing as a shell with only basic installations. There it was possible to construct fourteen additional guest rooms and two seminar rooms in the round towers. The interior design of the new guest rooms was attuned to the sophisticated design of the existing rooms through the use of stylistically appropriate furnishings and decoration.

A lift had to be included and was installed in the east wing. The entrance to the lift was on the north wall of the hall with the fireplace. The portico of the main building, which had formerly functioned as a small caretaker's flat or as rooms for watchmen, was in part remodelled as a lobby.

Since all solutions negotiated by the Architecture Division of the Max Planck Society with the Office for the

Ringberg Castle and the Max Planck Society

Preservation of Historic Monuments were accepted, Paul Löwenhauser, then head of the Architecture Division, wrote with unconcealed satisfaction in 1982 to Michael Petzet, Conservator-General of the Bavarian State Office for the Preservation of Historic Monuments: 'I am happy with this positive outcome. His Royal Highness, Duke Luitpold in Bavaria, left the castle to the Max Planck Society in an unfinished state. It can now be preserved and finished with the private funding secured by the Max Planck Society for a scientific conference venue. The sum concerned amounts to at least 4 million DM. With it, a historically significant Bavarian building can be preserved over the long term and fulfil a meaningful function.'

Restoring the Friedrich Attenhuber's paintings (1982/83)

While the construction work was going on in the main building, some seventy canvases by Friedrich Attenhuber that had been inventoried as belonging to the castle were restored. The paintings stored in Attenhuber's studio and in the main castle building since the painter's death in 1947 had sustained mechanical damage and were infested with mould due to poor storage conditions. Under the supervision of the Restoration Department of the Bavarian State Office for the Preservation of Historic Monuments, they were repaired and restored by Heide Grote. Some of these paintings were hung in the new guest rooms, the seminar rooms and the first-floor halls of the main building.

The conference venue opens (1983)

By spring 1983, that is, by 1 April of that year, the remodelling and completion of the castle had been finished so that it was once again ready for use as a venue for the exchange of scientific ideas. Professor Reimar Lüst, President of the Max Planck Society, welcomed an exclusive circle of guests, including quite a number of distinguished visitors from the Tegernsee and Kreuth valleys, to the official inauguration ceremony on 2 July 1983, which was a balmy, summery Saturday afternoon. Science, as Lüst emphasised in his inaugural speech, was not something that was conducted solely in laboratories or at desks. Scientists also needed intense one-on-one communication with fellow specialists, be they from their own institutes or from others, both in Germany and abroad. For that sort of communication to take place, however, centres in which they might meet were needed. German scientists had been persuaded of the usefulness of such centres both in the US and France as well as Italy '… yet hitherto we have had nothing comparable in the Max Planck Society'.

Horst K. Jannott, chairman of the board at Munich Reinsurance, who had been the instigator of the generous centenary donation to the Max Planck Society, made a point of saying in his own address that, in an age of electronic data processing and ubiquitous media, the greatest importance should be attached to the exchange of ideas, opinions and knowledge. 'I believe,' he went on to say, 'it is through linking what exists with careful yet thorough modernisation that it has been possible to create a place that can provide scientists with something, namely an opportunity to work in surroundings and in an open environment that stimulate the thinking that – if I may put it this way – ends them wings.'

Planning and building the conference rooms (1983–1985)

'What is still lacking is a large lecture hall,' remarked Reimar Lüst at the close of his inaugural speech of 2 July 1983. By then, the planning for the lecture hall had been completed. To make more space available for this purpose, architects Otto Meitinger – who at that time already held the chair for design and historic monuments conservation at the Munich Technical University – and Rudolf Ehrmann had worked out plans for 'constructing new conference rooms for the Max Planck Society'. They conceived a lecture hall that seated a maximum of eighty as well as side rooms. The large hall was to be used for lectures and discussions, slide and film shows and various other kinds of presentation. However, to create enough room for this new hall, an ancillary building had to be demolished.

The structure in question was the three-storey annexe housing offices that had been built on to the north-west tower of the main building in 1958/59, but had not progressed beyond the shell stage. Architecturally speaking, it was a rather awkward conglomerate that had been intended to encompass a cinema and did accommodate a bowling alley (fig. 134). It would have been interesting in as much as it might have conveyed some idea of the entertainment that its builder evidently wanted to provide for his – probably imaginary – guests. The bowling alley had been built into the slope as a bar-shaped structure. It had been finished in 1960 with what was called the Birthday Tower, which had been built on the occasion of Duke Luitpold's seventieth birthday. The bowling alley was now sacrificed to make way for the new lecture hall and was replaced by a pergola. The Birthday Tower, however, was left standing. (fig. 135)

The new hall – the topping-out festivities were held on 18 October 1984 – was erected on the site of the build-

130 Ringberg Castle. Rebuilding the battlements, part of which collapsed in 1985

ing that had been torn down in 1983 abutting the castle's north-west round tower. A simple building, affixed to the north castle wall, the lecture hall boasts a shed roof inclined against the north wall of the castle as well as two entrances. The lecture hall can be entered either via a stair within the north-west corner tower and the small lobby or directly via an outside stair attached to the west retaining wall on the slope. Between the lobby and the lecture hall are a kitchenette for making coffee and tea and a room for storing chairs. Abutting the lecture hall to the west, a partly roofed-over open space was created through adroit exploitation of topographical features.

The one- to two-storey structure is articulated by the three-dimensional configuration of the various functional areas and the shed roofs being on different levels. The façade and roof surfaces match the corresponding features of the main castle building in material and execution. The southern façade sports a sundial with a calendar designed by the sculptor Blasius Gerk as the overdoor to the hall entrance.

The walls enclosing the rendered building rest on solid bedrock. To match the rest of the building, the roof of the new structure was covered in larch shingles. The lecture hall itself is a simple room panelled in natural-coloured wood. The ceiling is a wavy dropped construction. The only historicist element is the oriel-like fenestration.

Rebuilding the south battlement and its bastion (1987)

In summer 1985, part of the 1930s southern battlement collapsed. For safety reasons, that entire section of the wall and the abutting bastion ultimately had to be demolished and removed. The retaining wall also needed to be shored up and restored. As the Max Planck Society Architecture Division saw it, a somewhat lower new battlement would have to be erected and the parterre garden would have to be set lower on the slope. The Office for the Preservation of Historic Monuments, on the other hand, insisted that the battlement with its bastion would have to

be reconstructed and rejected the idea of moving the parterre further down on account of art-historical considerations, since it derived from the idea of the Baroque parterre. Further, eligibility for tax exemptions or reductions was made contingent on faithful reconstruction of the original structures.

Due to this divergence of ideas, rebuilding measures were delayed but completed in 1987. The parterre garden was set slightly lower on the slope for reasons of statics, and 'reconstruction' saw an extra merlon and crenelle added to the battlement.

Rebuilding and fitting out the so-called Guest Tower (1989–1991)

Erected between 1920 and 1922, the architecturally impressive structure known as the Guest Tower was a free-standing keep with five storeys. However, after the exterior had been completed, it had been left an empty shell. Nevertheless, a studio had been set up on the first floor for Friedrich Attenhuber, which he continued to use until he died in 1947. This simple room, which, for all its spartan austerity, was equipped with a tiled stove, was still being used in 1988 to store the artist's materials.

For reasons related to the urgently needed restoration and conservation measures, the Max Planck Society also opted to finish the interior of the tower to create seven guest rooms there. The construction work was carried out from 1989 to 1991; the outer walls were reinforced and the Tower had to be fitted out with a corset of reinforced steel up to the level of the attic storey to carry the weight of the ceilings. Hence the appearance of the Tower remained unchanged. All that had to be added to the exterior was a fire escape.

Restoring and finishing the wash house (1989–1991)

The old wash house that was built in 1923/24 along with the gatehouse and the chapel, had also been left a shell. This little building with hewn-stone walls had been made to look like a hermitage. Between 1989 and 1991, the Max Planck Society had it converted into living quarters for staff, after the Bavarian State Office for the Preservation of Historic Monuments had refused to approve demolition.

Restoring and finishing the castle chapel (1989–1991)

The castle chapel was built in 1923/24 as a small, stucco hall church, with the chevet in the east and the alignment of the west tower deviating from the central axis and sporting an octagonal superstructure surmounted by an onion dome. The chapel, which was modelled after small 17th-century Bavarian rural churches, was left a shell while Duke Luitpold was still alive, although Friedrich Attenhuber had made sketches and designs for the chapel and had even completed cartoons for interior murals based on the Duke's instructions: 'There must be a St Martin, a St Leonard, a St George and a St Francis with his birds in the chapel.'

In the 1960s, the Duke commissioned the architect Heinz Schilling to paint a replica of the wooden ceiling of the pilgrimage chapel of St Servatius on Mt Streich in Chiemgau on the ceiling of the Ringberg chapel. Heinz Schilling reported animated discussions with the Duke about the design of the chapel interior. By that time, the altar wall was standing.

From 1988, the Max Planck Society discussed the various possibilities of restoring the chapel and the uses to which it should be put. In 1989, Paul Löwenhauser, head

131 Ringberg Castle. The chapel interior, completed from 1989 to 1991, has become a place for reflection.

Between science and conservation

of the Max Planck Society Architecture Division, applied to Conservator-General Michael Petzet: 'Since this [chapel] is no longer needed as the ducal house chapel, we would like to create a room that might serve as a space for meetings between science and religion at the express wish of both the Lutheran and the Roman Catholic churches. The churches are willing to cover the costs incurred. However, they have agreed to do so on the condition that the interior be neutral in design and the liturgical appointments moveable, depending on the events taking place in the chapel. The altar wall existing in the shell of the building precludes any thought of such possibilities. Consequently, I request that you consent to our removing it. Otherwise there is no chance of the desired construction work being financed.' The Office for the Preservation of Historic Monuments argued for the retention of the altar wall, but acquiesced 'with regret' in its removal. However, the Historic Monuments Office did insist that the ducal pew and the gallery with its stair at the back be kept.

Professor Otto Meitinger was one of the experts engaged in restoring and redesigning the chapel. To ensure that the interior was in line with contemporary tastes, that is, simple and clear in conception as well as non-denominational, the altar wall was removed and the chapel interior was lined with a shell of facing brick rendered in white slicker with a semi-cylindrical chevet in the east. A gallery, new towers and a coffered pine ceiling were also added. To make it more accessible, the chapel building was left surrounded by open space.

Within a space of just over ten years, the castle complex on the Ringberg had been restored and converted into an efficient and productive conference centre. Now thirty-four rooms were available as guest rooms. Seven of these are double rooms, which means that the castle complex boasts overnight accommodation for forty-one guests.

The Max Planck Society made it possible for the castle, which was not put to use in the conventional sense during Duke Luitpold's lifetime, to be made into a place that is filled with life. That is also a gratifying outcome when viewed from the historic monuments angle, because a structure on the scale of this castle complex can be preserved and maintained over the long term only if it is put to a meaningful use. Moreover, Ringberg Castle, which is situated on what is, from the topographical standpoint, beyond all doubt the most scenic site in the historic Tegernsee valley, can also contribute substantially to scientific circles by being such an important centre for the exchange of ideas.

'WITH THE TIMES'–
RINGBERG CASTLE, THE MAX PLANCK SOCIETY AND CHANGES IN TASTE
Otto Meitinger, former president of the Technische Universität Munich

HOW DID THE MAX PLANCK SOCIETY OBTAIN RINGBERG CASTLE?

My first contact with Duke Luitpold came about in the early 1960s, when I was working on the reconstruction of the Munich Residence as a young architect with the Board of Works. Baron von Gumppenberg, former president of the Bavarian Castles Administration, had received an inquiry from the Duke about having an expert's report drawn up on whether his Tegernsee castle, Ringberg, was eligible for listed monument status. Presumably because he realised how problematic such an appraisal might be, Baron von Gumppenberg delegated the task to me. Since at that time I felt unable to develop any intimate relationship with the stylistic conglomerate that was Ringberg, I chose to emphasise the art historical significance rather than the aesthetic value in my report. The Duke wanted Ringberg Castle to be granted historic monument status because that would have ensured tax exemptions. The expert's report was partly successful because, through it, Ringberg Castle achieved public recognition as an important building and from then on I was on good terms with the Duke. In subsequent years he asked me for my advice several times when he had questions about architecture.

During that time, I noticed that the Duke was worried about what would happen to his castle after his death. He was looking for an heir on whom he could depend that his castle would remain in essentials what it was. The German Trades Union Congress, which made the Duke an offer to buy it, did not, as he saw it, meet his expectations; nor did his basically conservative attitude augur well for sale to a trades union. Moreover, both the parish of Kreuth and the city of Munich politely rejected the Duke's offer in view of the costs that would have been incurred had they accepted it.

Since 1963, I had been head of the Department of Architecture at the Max Planck Society, so it seemed only logical that I would introduce the Duke to the then president of the Max Planck Society, the biochemist Adolf Butenandt. The idea that Ringberg Castle might someday be a scientific institution appealed strongly to Duke Luitpold.

Adolf Butenandt and even more so his successor as president, the physicist Reimar Lüst, were from the outset receptive to the idea of inheriting a conference venue for the Max Planck Society in a setting as magnificent as the countryside around Ringberg. Even before his tenure as president, Reimar Lüst was acquainted with the Ringberg and the castle: he had a house on Tegernsee, from which he had an unobstructed view of the castle. He would have the good fortune to be president long enough to inaugurate the conference centre in 1983. For a long time, this enthusiasm for the idea was not held unanimously within the Max Planck Society. At an administrative council meeting, the then treasurer suggested selling the castle as soon as it should become the property of the Max Planck Society. A particularly influential member of the council also expressed considerable scepticism about whether the Max Planck Society really could afford a centre of its own for hosting events such as symposia.

On that occasion, doubts also surfaced about whether and to what extent scientists from Max Planck institutes would actually make use of a conference centre located in the deep south of Germany and, therefore, such a long journey away from anywhere. Proposals that Ringberg might also be used as a conference centre by the German Research Foundation, the Scientific Council, the academies of science and letters and both universities in Munich represented attempts made to overcome objections that Ringberg Castle might not be used frequently enough to make owning it worthwhile.

It is undoubtedly due to Professor Lüst's persistence in championing the idea of a conference centre at Ringberg Castle that an agreement to accept the legacy was finally concluded in 1967, by means of which Duke Luitpold made the Max Planck Society heir to what he possessed on the Ringberg after his death. Since the Duke

had bequeathed a considerable fortune along with the complex's entire holdings, the financial experts on the administrative council found it easier to accept the legacy. This ensured that the Max Planck Society would not be burdened with the upkeep of the buildings. Even today the castle is entirely maintained by this endowment, which is now known as the 'Luitpold Fund'.

Duke Luitpold died at the age of eighty-three in 1973, whereupon the castle came into the possession of the Max Planck Society on condition that it would be used for scientific purposes. At that time, there were twelve completely furnished and decorated rooms in the main building. It was wise of President Lüst to opt for using these rooms temporarily for conferences on a small scale. Ringberg Castle was used in this way from 1974 until 1980 before construction work began on the site. This long 'trial phase' soon made the Max Planck institutes familiar with Ringberg.

In my capacity as dean of the architecture faculty at the Munich Technical University, I along with colleagues from the faculty also benefited from that first phase of use. The prevailing conditions were, however, far from the service available today: to spend a weekend there, we even had to bring our own bed linen with us and our wives contributed cakes for afternoon coffee. The architecture professors from the Munich Technical University, therefore, had their share in using Ringberg Castle as a conference venue during that pioneering phase.

This transitional stage lasted until 1980, when the Max Planck Society finally had the wherewithal, thanks to a large donation from Munich Reinsurance, to start remodelling the castle. The second storey and the Guest Tower were finished so that today a total of thirty-four

132 The conference centre is inaugurated on 2 July 1983. In front are Professor Otto Meitinger (left) and Horst K. Jannott (right), chairman of the board of directors of Munich Reinsurance

guest rooms are available. By the mid-1980s, Ringberg Castle had finally become a scientific conference centre with amenities meeting the most exacting standards when a seminar and lecture-hall building was erected in the north tract of the castle, with its entrance in the west round tower. Although I had been employed at the Munich Technical University since 1977, the planning for this lecture hall dates back to my Max Planck Society days. The design itself was worked out with my Technical University colleague Rudolf Ehrmann in collaboration with the Max Planck Society's Department of Architecture. To make room for the new structure, which also left the round tower free-standing again and ready for use as an entrance, several unfinished ancillary buildings associated with the original castle complex that were not, however, integral to its overall appearance, were demolished. The lecture hall seats up to sixty; this technical limit is also responsible for creating what is still the almost intimate atmosphere that prevails at conferences held at Ringberg Castle.

During the lifetime of Duke Luitpold in Bavaria, Ringberg Castle was never used in the conventional sense. In fact, the castle hardly welcomed any guests to speak of. A local Tegernsee writer once eerily described Ringberg Castle as a 'stony labyrinth of silence'. Nowadays things have completely changed; Ringberg is like a boutique science hotel. There is no doubt that not only the inhabitants of Tegernsee and Kreuth but also of Bavaria as a whole are now grateful to the Max Planck Society for having filled Ringberg Castle with life. This is also an enormous bonus from the historic-monuments angle because a complex the size of Ringberg Castle can only be maintained over the long term if it serves a meaningful purpose that is commensurate with the importance of the building.

'WITH THE TIMES' – ASSESSING RINGBERG IN CHANGING TIMES

'With the times' was Duke Luitpold's personal motto, which should probably be interpreted as 'Keep abreast of the times'. This motto is writ large in the Ringberg Castle dining room. It is an astonishing device for someone who embarked in the 20th century on building a villa that would morph into a fortress and ultimately a sort of castle.

The motto can, however, also stand – not without a slight touch of irony – for the dramatic changes in taste that have occurred since then, to which our aesthetic judgement is subjected. 'With the times' our taste and our view of things change considerably and we are all subject to the passage of time even though we are often unwilling

133 Ringberg Castle. The stair in the north-west tower leading to the lecture hall built in 1985

to admit it. The most telling example is the changing appreciation of Art Nouveau: as recently as the 1960s, the historic-monuments authorities looked on indifferently as the stucco was chipped off the most beautiful Art Nouveau façades in Munich's Schwabing district, for example, because unadorned functionalism was regarded as modern.

My personal opinion of Ringberg Castle has also changed: whereas on first sight – as I mentioned above – I was unable to summon up any emotional affinities with the eclectic blend of styles, I see Ringberg Castle with different eyes today: it stands primarily for the quest for new forms of artistic expression that drove the first half of the 20th century. Nor is it possible to foresee how future generations may someday judge Ringberg.

Ringberg Castle has remained to this day an admittedly unconventional but undoubtedly highly remarkable architectural complex. In essentials it has been enlarged only by the addition of the new lecture hall. Since the interior design, including all pictures hanging there, are the work of the Duke's personal artist, Friedrich Attenhuber, Ringberg is indeed a very idiosyncratic total work of art by any standards. The impression Ringberg Castle makes today would presumably be gratifying even to the Duke himself.

134 A model of Ringberg Castle: the north-west tract before the conference hall was built. The view of the north-west tower used to be blocked by ancillary buildings.

135 A model of Ringberg Castle: the north-west tract with the new conference hall

Ringberg Castle represents the fulfilment of a romantic architectural dream, which the Duke upheld all his life while growing more estranged from reality. As a result, Ringberg Castle should not be judged primarily by utilitarian standards: because the Duke was mainly concerned with the appearance of the complex as a whole and any money available at a given time was used for building new structures, many of the interiors remained unfinished, including the second floor of the main building, the keep and the chapel. In continuing to undertake new building projects, the Duke was striving, on the one hand, to finish off the overall appearance of the complex – while constantly bringing new ideas back from his travels to be incorporated into it.

He may even have initially entertained some idea of giving the House of Wittelsbach a new family seat, an architectural focus for the dynasty that had reigned in Bavaria for almost eight centuries without interruption. Wittelsbach Castle, from which the family name derives, had ceased to exist quite some time before construction work began at Ringberg.

It might also be viewed as tragic that Duke Luitpold had to build in the 20th century. Had he lived in the 18th century and had he found an architect like Balthasar Neumann, Luitpold would certainly have made architectural history with Ringberg Castle. But even so, as a total work of art that is a distillation of all art movements and period styles from the first half of the 20th century, Ringberg Castle is of art-historical and cultural interest. For all its stylistic eclecticism, Ringberg Castle is still undeniably remarkable both for its site-specific relevance and originality as architecture and the evidence it furnishes for the creative powers evinced by its first owner and the artist who worked for him.

RINGBERG CASTLE TODAY –
RECOLLECTIONS OF EXTRAORDINARY SCIENTIFIC CONFERENCES

Manfred Rühle, Max Planck Institute (MPI) for Metals Research, Stuttgart

FIRST ENCOUNTER WITH RINGBERG CASTLE

In 1980, Australian materials scientists discovered a phenomenon that attracted a lot of notice and caused a great deal of excitement in ceramics research circles. In an article in the respected journal Nature, they described a process they called 'transformation toughening', by means of which the most common 'disease' of ceramic materials, brittleness, might be effectively combatted.

Since not much is known in this field about the mechanisms governing hardness, and what is known is for the most part not understood, the desire soon arose to convene a small group of top scientists from various fields related to materials science at a discussion forum and conference to shed some light on the various facets of the new process. This conference was to be interdisciplinary in character. Alongside materials scientists, physicists, physical chemists, materials engineers and engineers were to represent their respective fields. Günter Petzow, Nils Claussen and I (from the MPI for Metals Research) offered to organize the little conference together with Arthur Heuer (of Case Western Reserve University in Cleveland, Ohio). The twenty workshop participants were soon found. Nor was it a problem at the time to arrange to have the necessary funding, provided by the Deutsche Forschungsgemeinschaft (DFG) and the Max Planck Society. But it was not easy to find a suitable and attractive conference venue for the dates desired (in June 1981). Then a colleague from a Munich Max Planck Institute drew our attention to Ringberg Castle.

Since Ringberg Castle was not yet well known as a conference venue, we went to Tegernsee in mid-January 1981. From the lake shore we saw the castle nestling against a mountain backdrop on an outcrop of the Ringberg in a gloriously snowy Alpine setting. The massive grey towers and the main building stood out sharply against the mountain panorama. We found our way to the hidden path that wends its way up to the castle. Even on our first visit, Ringberg Castle intrigued us with its spacious layout. The high, grey walls surrounding the castle proper looks as if it were in an enclosed space, in a 'labyrinth of stone', shut off from the outside world. Above and beyond the walls, splendid vistas open up out across Tegernsee, the Kreuth valley and the grand surrounding mountain scenery. Despite the lack of any clearly defined stylistic uniformity, the historic rooms on the ground and first floors radiated such warmth that they made us forget the seasonal cold weather, even though the rooms had no heating at that time. We spontaneously decided to hold the planned symposium and conference at Ringberg Castle in June that year, although only about a dozen guest rooms were then available. Neither the second storey of the main building nor the keep had yet been fully converted; nor did the conference hall available today exist then.

Well, that first workshop took place from 16 to 19 June 1981. We were delighted to find that all the scientists, from around the world, that we had invited to participate accepted our invitation. That was highly unusual even then! Was it the exciting, cutting-edge subject matter of the workshop or was it the conference venue that attracted our colleagues? Max Planck heads were known to behave in the outside world as if they were 'monarchs of science' – and now to add insult to injury, a castle?

One problem we had to deal with was that not just the colleagues from the Stuttgart Max Planck Institute for Metals Research but also several distinguished professors had to be driven daily up the winding road between the B&Bs in the village and the castle. A vow of abstinence from the good Tegernsee beer – which probably was not always observed – was imposed on the young drivers, who were students from our institute. The upshot was some pretty reckless careening round those curves down into the valley.

The lectures and discussions were to be held in the Great Hall, which is now the dining room. Breakfast was served in what is now the breakfast room and in the

Witches' Room. The 'balcony room' also had to be used for the other meals. Since there was so little room in the lecture hall and the dining rooms had such a limited seating capacity, only thirty-five scientists could take part in the workshop. The maximum number of participants accepted our invitation so things were pretty cramped during the conference but this promoted intellectual exchange and lively discussion.

No sooner had the scientific community got wind of the discussion conference than the organisation team were deluged with queries about the possibility of angling an invitation. We turned down all additional requests on account of the limited capacity of the castle. A colleague from Berkeley, California, was particularly persistent, however: he simply drove up to the castle in a big car after midnight on the first day of the conference – having lost a lot of time trying to find his way to Ringberg. Since by then the massive main entrance was already bolted shut and there was not yet any night personnel to deal with such contingencies, the would-be gatecrasher and his wife were forced to spend the night at the gates in their car.

OUR FIRST CONFERENCE AT RINGBERG CASTLE: TRANSFORMATION TOUGHENING OF CERAMICS (JUNE 1981)

The invited participants arrived punctually in Munich for the start of the conference. Transport to the castle from Munich Central Station and from Munich-Riem Airport went off without a hitch. Their first sight of the castle left our guests standing slack-jawed with amazement. The grey walls, all the many buildings in the complex, were simply overwhelming. Unfortunately, a steady summer rain that lasted for three days set in simultaneously with our workshop, so we were almost always kept confined indoors in the castle. The heavens over Bavaria were probably displeased that the workshop was scheduled over the Corpus

136 The lecture hall in the new seminar building at Ringberg Castle is used for Max Planck Society conferences and events.

Christi holiday. Whenever the sky did happen to clear, however, we enjoyed the breathtaking vistas of the countryside around Tegernsee and across the Kreuth valley.

The conference began with lectures that provided introductory overviews of the field of research and highlighted points that were still unresolved or needed clarification. The lectures were often interrupted by questions. Some of them simply elucidated what had been covered up to that point; others represented critical evaluations of what was being said. Framed by antlers, the goddess Diana on the red marble mantelpiece looked down bemused on the distinguished company. Colleagues would occasionally look up at her beseechingly – if she would only silence with a well-aimed arrow the one or two wafflers who marred the beginning of the conference. Daphne, scantly clad in her efforts to ward off Apollo's tempestuous wooing, looked down from across the projection screen. A painting in the 'blood-and-soil' style depicted the Olympian gods in a Bavarian Alpine setting so grand that it somewhat moderated the impression made by the figures painted with such jarringly harsh realism. All the figures from mythology and history in the pictures assembled in the room seemed to be interacting with the lectures – a stimulating environment for an unusual workshop! The first day passed with flying colours. The lectures and productive discussions were interrupted only by delicious meals.

After the evening meal, discussions continued in a lively vein in the packed Witches' Room. This delightful cubic room furnished with rustic carved tables, benches and chairs and glorious tapestries depicting witches dancing on the Ringberg (Ringberg was the haunt of Bavarian witches renowned for their beauty) inspired further discussions. Apart from the room, the excellent Tegernsee beer, which in those days was still dispensed free of charge at the castle, played its part in lubricating tongues. Some of those who were still at it in the small hours swore they saw the witches in the lovely tapestries dancing in circles, a sight that spurred them on to 'even greater heights'.

Conference participants from the US especially took advantage of the opportunity afforded by the massive ducal desk to work out outlines of collaborative publications or write applications for grants to fund research projects dealing with the many issues left unresolved by the conference. They were all captivated by the fostering atmosphere at Ringberg Castle; some were even caught up in it.

The breaks were used by participants to divert their scientific curiosity to exploring the castle. Even though it was not always easy to figure out what some of the buildings were used for, they still fired the imagination. On the upper floor of the then not yet refurbished keep, colleagues found a stack a metre high of 1930s numbers of the British weekly magazine Country Life, which must have been left there by Friedrich Attenhuber, the painter and creator of Ringberg Castle.

The historic rooms on the first floor of the main building also made an impact. A colleague from MIT in Cambridge, Massachusetts, confessed the following morning at breakfast that a nude village beauty above his bed had robbed him of his sleep. The guest assigned to the ducal bedchamber was duly impressed by the dimensions of the vast room, with its sprawling bed and palatial bathroom, even though the broad edge of the bed frame with its sunken mattress and the steps that raised the bed even higher than it already was had proved difficult to negotiate. By the end of the workshop, he had a crop of bruises on his shins from having to clamber in and out of bed over that edge.

The remaining days of the workshop continued to be very productive. The mechanisms needed to understand 'transformation toughening' were ascertained, models were formulated and ways of dealing with problems were discussed as they came up. Considerable scientific advances were made during the conference. New links and friendships were forged between colleagues. A group of European and American participants formed that has remained in close contact to the present day and continues to exchange scientific information and results. The other participants fondly, albeit rather enviously, dubbed this circle the 'ceramics mafia'.

The workshop came to a festive close on a Friday evening with an excellent banquet laid out in the dining room. Up to then, we had 'misused' the room as our lecture hall. Above a fire roaring in the fireplace, Diana's wreathed face observed the goings-on in inscrutable silence. Daphne, too, no longer seemed to look down on us with such morose condescension. The end of the banquet marked the official close of the workshop. Nevertheless, as on all the previous evenings, a very, very prolonged late session was held in the popular Witches' Room. Once again, the little witches circled devotedly above the scientists' heads, presumably inspiring some of them.

It was hard indeed to take leave of Ringberg Castle. Extremely productive days had come to an end. The workshop had proved a success on a scale that had not been reckoned with. To be sure, the unusual ambience at the not yet completely refurbished castle with its lovely yet often provocative interiors had contributed substantially to

the success of the conference. The rain had prevented most conference participants from getting enough exercise even though the cuisine had been so excellent and the Tegernsee air had whet their appetites so nearly everyone took a doggy bag home with them.

CONFERENCES AND WORKSHOPS HELD AFTER RINGBERG CASTLE WAS RENOVATED

Generous funding from Munich Reinsurance made it possible to finish the second floor of the main castle building and the keep at Ringberg and even to add an auditorium. Thus a conference centre replete with state-of-the-art facilities and amenities was created. It became so popular among the members of the Max Planck Institutes that it was not long before it was booked up all year round as a conference venue.

On returning from the University of California, Santa Barbara, to the Max Planck Institute for Metals Research in Stuttgart in 1989, I tried that same year to schedule a conference week at Ringberg Castle – which was not always easy to do, yet ultimately almost always worked out! The first conference, in 1981, described above had been such a huge success that we all had the most glowing memories of it. But could this success be repeated?

In summer 1990, Ringberg Castle was again available to us for a week. The concept of this and all subsequent conferences and symposiums resembled that of the first. Together with colleagues, most of whom came from abroad, we selected a subject that matched our ongoing research projects yet could be suitably limited. An interdisciplinary approach was a major concern in planning conferences. We tried, usually with success, to secure leading specialists for the workshops – Ringberg Castle still exerted an enormous pull. We invited the scientists to hold a lecture and participate in the planned workshop even before the timetable had been worked out in detail … A notable feature was that everyone planning to give a lecture was permitted to bring one or two young scientists with him who were working actively in the selected field so they would also be able to answer detailed questions, usually in front of a poster at a poster session. This concept certainly proved its worth. Our workshops had a reputation that many feel surpassed that of the celebrated Gordon Conferences.

In June 1990, the first thing we noticed on entering the great stairwell was that the vast Friedrich Attenhuber mural portraying the two cousins Luitpold and Ludwig Wilhelm, Dukes in Bavaria, had been covered over by a thick tapestry that certainly did not match the style of the castle. Evidently the donor responsible for funding the renovation of the castle had been offended by the highly naturalistic picture. Be that as it may, the tapestry was banished years later.

Wonderful pictures, also painted by Friedrich Attenhuber, hung on the now-finished second floor. The magnificent paintings in the Impressionist style revealed Attenhuber from a side that differed markedly from the 'blood-and-soil' style of painting he had adopted from about 1930. What had induced Friedrich Attenhuber to make that incomprehensible change? Was it after all an expression of his anger at the Duke? That question will probably never be entirely clarified.

The new rooms on the second floor of the main building were conservatively yet tastefully decorated. As a bonus, discussion rooms were now available in the corner towers of the main structure. The new lecture hall was handsomely proportioned; the more stringently formal setting provided by the new auditorium was also planned to accommodate discussions.

Some of those workshops were particularly successful. In 1993, we presented state-of-the-art findings on aluminium oxide (alumina), an important structural ceramic. The impressive advancements that resulted from that first symposium were presented at another workshop, held in 1998.

Another workshop, held in 1996, resulted in the Max Planck Society concluding an agreement with the materials scientists at the University of California, Santa Barbara, on long-term collaboration and student exchange.

Finally, a 1999 workshop on 'wetting of solid surfaces and internal boundaries' convened an impressive array of theorists as well as experimental scientists working in fields related to surfaces and interfaces. Extensive collaboration between various groups, especially from outside Germany, as well as outstanding publications developed out of that workshop.

WHY ARE THE RINGBERG CASTLE WORKSHOPS SO SUCCESSFUL?

We have often been asked why the Ringberg Castle workshops are so successful in building bridges. The remote location of the castle has definitely plays a role in this. Screened off from the public eye behind its high walls, excellent discussions can be held without fear of distur-

bance. Unfortunately, there as everywhere now, the internet has also come into the picture. That it should do so is to be expected nowadays, yet workshop participants being involved with e-mails during lectures and discussions is a nuisance.

What has never ceased to impress us is the work accomplished by the 'benevolent spirits' at the castle. Axel Hörmann, director of the conference venue, and his small but skilled team are, in my view, the ideal coordinators for a special conference venue. Not only do they ensure that workshops can be run without a hitch. They also try to fulfil every wish as far as possible. Once, when we were at the castle, on 11 November, we requested that the special noon meal (Bavarian white sausages and Tegernsee draught beer) be served early, at 11.11 am. The 'Benevolent Spirits' smiled on us and saw to it. The early noon meal tasted wonderful and lent wings to the scientific discussion held that day.

We should, therefore, like to express our gratitude to Axel Hörmann also in the name of all those who have participated in conferences at Ringberg Castle, for the excellent and friendly ambience he and his team have created there. The Bavarian witches prancing above the castle have definitely made the wheels revolving in the scientists' heads go round faster.

OBSERVATIONS MADE BY COLLEAGUES ABOUT OUR WORKSHOPS ON THE RINGBERG

Early in March 2008, I asked several colleagues who had often participated in workshops, to jot down a few lines about Ringberg Castle and our workshops.

Professor Fred F. Lange (Materials Department, University of California, Santa Barbara, CA):

My first experience at Schloss Ringberg was in 1981, at the first workshop on transformation-toughened zirconia. Although other workshops and conferences on this same topic were later held in different parts of the world, the one at Ringberg established much of the science of this new phenomenon that enables a tough and strong ceramic. Because this was one of the first meetings at Ringberg, the castle was unfinished relative to today's venue. In 1981, our daily discussions were held in the current dining room, with a square arrangement of tables, a slide projector near the center, and a flimsy screen at one side. We ate wonderful meals, as today, in the room currently used for the buffet breakfast. The cabinet used to stock beer and wine is well remembered and where it is located today. Yes, I still remember my first bottle of Tegernsee beer, and the beer hall in town, which I visited during a subsequent workshop.

During this first visit, I had the opportunity to walk around the castle with an older and notable professor from a well-respected East Coast university. I remember climbing the unfinished turret, now filled with rooms, to find a stack of the English magazine, Country Life, from ca. 1935; the stack was at least a meter high. Approximately 10 years latter, I had a chance to walk around the now finished Schloss with the same senior professor. I reminded him of our previous excursion, and asked if he remembered the unfinished turret and finding the tall stack of Country Life. He replied, 'Yes, I took one!'

During subsequent visits to Schloss Ringberg, I remember Herr Hörmann's gracious welcome, his tour, which I almost always attended, and his warm hospitality. A roaring fire was always present during the winter. On one visit, I was assigned the Duke's room. Tired from the long air trip, and feeling unclean, I decided to take a bath before dinner. The Duke's bathtub is long enough to allow one to completely lie down, as if in a bed. I filled the tub with enough hot water so, while lying down, the water would not cover my nose. The bath was so relaxing that I fell asleep. I woke up about an hour later feeling cold, and found all the water had drained away. Later at dinner, a few participants suggested I could have drowned and it was a good thing that the water did drain away.

Yes, you can think of Schloss Ringberg as our scientific home, a home for discussion of new science and a home for making new friends and greeting old friends once again. Schloss Ringberg is certainly unique. If its halls could have learned what was said, they would be teachers of discoveries witnessed in the past.

Professor David Clarke (Materials Department, University of California, Santa Barbara, CA):

To me, Schloss Ringberg is not only my favorite conference and workshop venue but also the most perfect. It's secluded but not remote, it's timeless but not stuck in time, and the housekeeping is outstanding but not obtrusive. It's also the right size so everyone can meet one another either over one of the meals or in the nooks and crannies and small rooms during the course of several days. This really facilitates an intimate workshop atmosphere and exchange of ideas. Then, there are the excellent meals, ranging from the large variety of German breads at

137 Interesting encounters: young scientists in the Great Hall at Ringberg Castle

breakfast to the fine German lunches to the grand workshop dinners.

I've been at workshops at Ringberg in the Fall, Winter and Spring. I've stayed in the 'tower', on each floor in the main building and, once, even in the Duke's bedroom, and I've probably had scientific discussions in every room (except for the swimming pool, which has never been filled during my visits), but for me, my favorite times have been having coffee on the terrace after lunch overlooking the distant mountains and the late night hours over beer in the small rooms. There, I've had discussions and arguments with almost every materials scientist I know, renowned and not so well known. Each workshop has been a formative event and I treasure memories of each and every one.

Finally, many people compare scientific meetings to Gordon conferences, but for me the golden standard are workshops at Schloss Ringberg!

Professor Antoni Tomsia (Lawrence Berkeley Laboratory and the University of California, San Francisco, CA):

Schloss Ringberg meetings organized by Manfred Rühle were considered the most prestigious gatherings in materials science during the eighties and nineties. If my memory serves me right, I started attending these meetings more than 15 years ago. Yes, there were some other meetings, like MRS, TMS, Gordon conferences, American Ceramic Society, and countless others, but they are so large that it is impossible to attend all the talks that seem relevant to my research interests. Schloss Ringberg, on the other hand, was always very focused, dedicated to one particular subject, which made it much more interesting. Most importantly, being in one location and separated from the crowds, permitted ample time for discussions with friends and colleagues. This was actually the finest part of these meetings, as people were free to talk, seeking help in

explaining various experiments for which the common understanding was missing. The vision of Manfred Rühle was to provide a forum where eminent international researchers from various fields can interact for a week away from e-mails and phone calls, and concentrate on discussing pure science. Formal and informal interaction with key international experts provided the stimulus to progress in specific areas of research, while allowing new entrants to the field useful insights into fundamental and advanced developments. As for new entrants, we were always encouraged to bring students and postdocs to Schloss Ringberg, which made this meeting so useful for a new generation of scientists. I truly miss these meetings, as they always delivered plenty of challenges for the future. Looking back, I can see now that these meetings were really designed to develop a practical solution to problems that critically depended upon as yet undeveloped basic science. The meetings I attended always began with presentations that emphasized what specific gaps exist in our present knowledge and then looked broadly for advances that would enable us to bridge them. This made Schloss Ringberg conferences genuinely unique.

More importantly, Schloss Ringberg workshops always emphasized materials science as a team effort of scientists from many different disciplines, and recommended that, to further advance the field, we need new mechanisms that would foster truly interdisciplinary collaboration. We hear continuously these days about the bio- and nano revolution, which has certainly taken our field by storm. What is not known is that these topics were extensively discussed at Schloss Ringberg long before they became fashionable. Therefore, a key focus of many workshop presentations was to define new directions for many materials systems. Critical open scientific questions were explained and future directions for research were highlighted.

THE AUTHORS

HELGA HIMEN was born in Austria and worked as a journalist immediately after leaving school with a university-admission qualification. She studied art history, sociology, philosophy and theatre in Heidelberg and Munich, where she took her MA degree at the Ludwigs-Maximilians-Universität. At the Bavarian State Office for the Preservation of Historic Monuments, where she was employed from 1976 to 2007, she was primarily responsible, in her capacity as adviser to the Cataloguing Department, for recording and researching historic buildings in the Bavaria capital. Within the diverse field of historic-building preservation in an urban environment, the art historian's work and research focused on Munich's architectural history – especially developments that took place during the so-called Third Reich and after 1945 – much of which has appeared in specialist publications. During her tenure, Helga Himen worked on her doctoral dissertation dealing with Ringberg Castle on Tegernsee, which was supervised by Professor Dr J. A. Schmoll called Eisenwerth, and involved drawing up a comprehensive inventory of the furnishings and appointments of the main castle as well as conducting research on castles built in the 19th and 20th centuries.

HEIDEROSE ENGELHARDT studied art history and took her doctorate in Leipzig. Since 1992 her freelance activities have included working as a writer, editor and reader for the Deutscher Kunstverlag in the field of art books and museum guides.

OTTO MEITINGER studied architecture in Munich and from 1953 was in charge of rebuilding the Munich Residenz. From 1963 until 1976 he was head of the Architecture Department at the Max Planck Society. In 1976 he was appointed professor of design and the preservation of historic monuments at Munich's Technical University, where he established a foundation course in the preservation of historic buildings. From 1987 until he retired in 1995 he was president of Munich's Technical University. Buildings remodelled after his designs include the Villa Hammerschmidt in Bonn and Bellevue Palace in Berlin. Otto Meitinger is a member of numerous specialist boards and societies, has been decorated with the Bavarian Maximilian Medal for Science and Art and – in addition to many other distinctions – was given the freedom of the city of Munich in 2005.

MANFRED RÜHLE was head of the Department of Phase Transformations and Reactions at Interfaces between Metals and Ceramics at the Stuttgart Max Planck Institute for Metals Research from 1989 until he retired in 2005. He was executive director of the institute from 1994 until 1999. He had previously cofounded the Max Planck Institute for Microstructure Physics in Halle (Saale), where he was a temporary director from 1991 to 1993. Two stints at the Argonne National Laboratory and the University of California in Santa Barbara have enabled him to forge and maintain close links with colleagues abroad. The American Institute of Scientific Information database of most highly cited scientists lists him as one of two hundred and eighty most highly cited scientists in materials science, and he has been the recipient of all prizes awarded by the American Ceramic Society.

PHOTO CREDITS

Bayerisches Landesamt für Denkmalpflege, Munich
Frontispiece, 25, 38, 64, 84, 76, 101 (Joachim Sowieja), 117 (Eberhard Lantz)

Bayerische Verwaltung der staatlichen Schlösser, Gärten und Seen, Munich
104

Dr Heiderose Engelhardt, Munich
45, 80

Dr Helga Himen, Munich
4, 5, 6, 8, 16, 26, 27, 28, 32, 35, 36, 42, 43, 44, 50, 54, 57, 62, 74, 75, 81, 82, 107, 124, 125, 128, 130

Manfred Manke, Gmund am Tegernsee
Front cover, 3, 51, 53, 59, 61, 63, 65, 66, 69, 70, 72, 77, 79, 93, 103

Max Planck-Society, Munich
S. 7; 1 (Hermann Rupp, Oberstdorf), 7, 9, 13, 14, 19, 21, 24, 33, 34, 39, 40, 41, 48, 49, 55, 56, 87, 88, 89, 90, 99, 110, 116, 121, 123, 126, 127, 129, 131, 132;
83, 91, 92 (Picture editing Liv Engelhardt, Coburg)

Dr Kai-Uwe Nielsen, Munich
End papers, 10, 11, 12, 15, 17, 18, 20, 22, 23, 29, 30, 31, 37, 46, 47, 52, 58, 60, 68, 71, 73, 78, 85, 86, 94, 95, 96, 97, 98, 100, 102, 105, 106, 108, 109, 111, 112, 113, 114, 115, 118, 119, 120, 122, 133

Susanna Schaffry – photographer
67, 136, 137

from: *Otto Meitinger. Architekt – Denkmalpfleger – Hochschullehrer.* Issued by Technische Universität Munich, 1997
134, 135

from: *Das Tegernseer Tal in historischen Bildern und Ortsgeschichten der Talgemeinden. Beiträge über Land, Leute und Begebenheiten rund um den See.*
Hausham 1980
2